SHARING HONORS AND BURDENS

Renwick Gallery *of the*
Smithsonian American Art
Museum, Washington, DC,
in association with University
of Washington Press, Seattle

Lara M. Evans

Miranda Belarde–Lewis

Anya Montiel

foreword by Stephanie Stebich

SHARING HONORS AND BURDENS

Renwick Invitational 2023

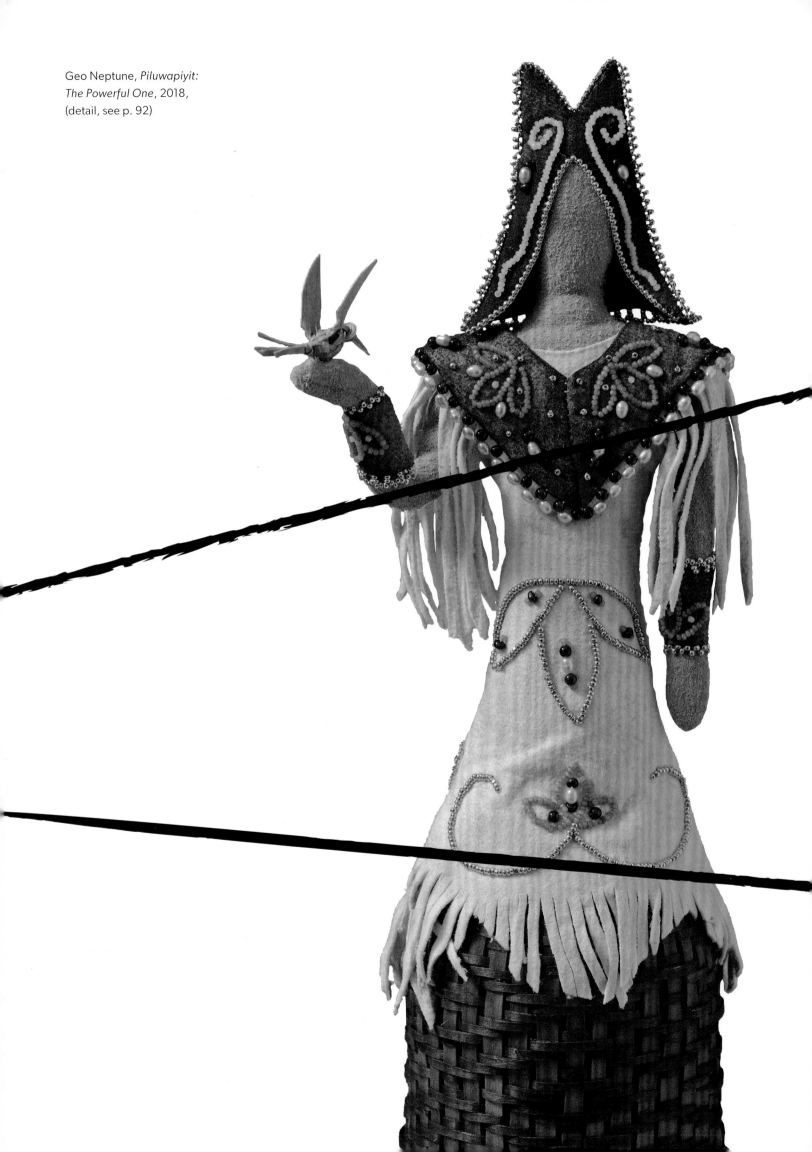

Geo Neptune, *Piluwapiyit:*
The Powerful One, 2018,
(detail, see p. 92)

The Ryna and Melvin Cohen Family Foundation Endowment provides support for the Renwick Invitational. The Cohen Family's generosity in creating this endowment makes possible this series highlighting outstanding craft artists who are deserving of wider national recognition.

Additional support has been provided by:

Elizabeth Firestone Graham Foundation

Lannan Foundation

The Robert Lehman Foundation

Smithsonian's National Museum of the American Indian

The Andy Warhol Foundation for the Visual Arts

Windgate Foundation

Wyeth Foundation for American Art

The Andy Warhol Foundation for the Visual Arts

Contents

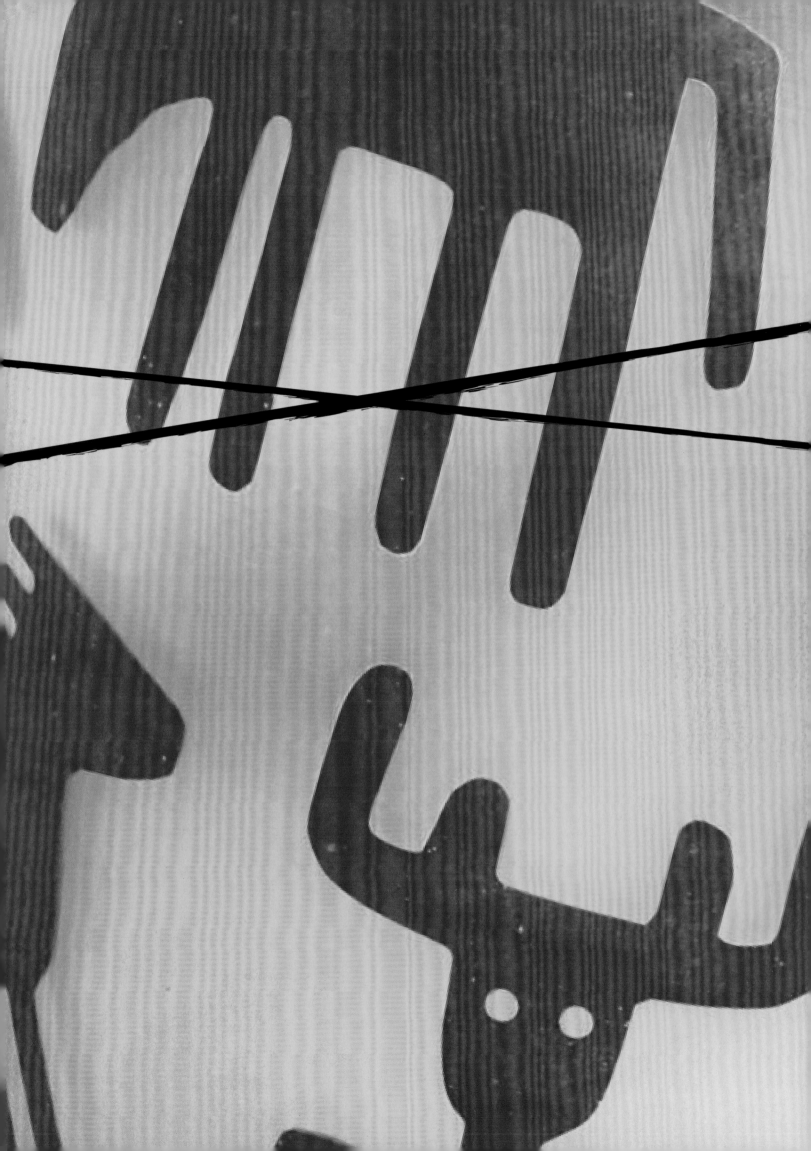

Stephanie Stebich

The Margaret and Terry Stent Director
Smithsonian American Art Museum

Director's Foreword

Joe Feddersen,
Horses and Deer,
2020 (detail, see
p. 26)

LAUNCHED IN 2000, the Renwick Invitational series showcases emerging and under-recognized artists of American craft. This year's installment, *Sharing Honors and Burdens*, features Native American and Alaska Native artists for the first time. The spark for this Invitational was ignited in spring of 2020, when the widely acclaimed traveling exhibition *Hearts of Our People: Native Women Artists* closed unexpectedly early due to the COVID-19 pandemic. *Hearts of Our People* reinforced a commitment by the museum to contemporary Native American artists and Indigenous voices. Given this lost opportunity, we pledged to prepare our own exhibition as soon as possible. The 2023 Invitational provided the perfect occasion to highlight remarkable work being done by Indigenous makers today, from Alaska and Washington State to Colorado, New Mexico, Minnesota, and Maine.

The 2023 jurors—Lara Evans (Cherokee), Miranda Belarde-Lewis (Zuni/Tlingit), and Anya Montiel (Mexican/Tohono O'odham descent)—carefully chose six artists out of countless others from Indigenous Nations across the United States whom they felt deserved wider recognition in the field of contemporary craft. Evans, who is guest curator for this year's Invitational and director of the Research Center for Contemporary Native Arts at the Institute of American Indian Arts, along with Montiel, curator at the

Smithsonian's National Museum of the American Indian, and Belarde-Lewis, the Joseph and Jill McKinstry Endowed Faculty Fellow in Native North American Indigenous Knowledge at the University of Washington's Information School, chose the theme sharing honors and burdens to unite the artists' work.

Drawing from customary techniques and traditional knowledge, the artworks—many of which were created just within the past year—are both innovative and deeply aligned with contemporary experience. While each artist uses different craft materials and techniques to explore a range of topics, all create work that speaks to personal and communal honors and burdens and reflects on the responsibility of sharing these with the wider world.

Joe Feddersen (Arrow Lakes/Okanagan), whose glass basket *Horses and Deer* the museum recently acquired, incorporates symbols distilled from everyday life into beautiful glass works, prints, and fiber pieces. In his installation, *Charmed (Bestiary)*, Feddersen combines seemingly disparate motifs, from depictions of animals and human figures to biohazard signs and the microscopic image of SARS-CoV-2, to create a kaleidoscopic and cacophonous "glass line drawing" of our world. Through careful placement, the charms seem to interact, connecting and juxtaposing in clever and surprising ways. In other works, Feddersen puts a modern twist on forms like fish traps and baskets, objects customarily created for use in Plateau communities of the Pacific Northwest. I am delighted he is included in this exhibition, as I have known and admired Feddersen's work for years.

Sisters Lily Hope (Tlingit) and Ursala Hudson (Tlingit) learned their weaving skills from their mother, master weaver Clarissa Rizal. Labor-intensive and time consuming, their Chilkat and Ravenstail weaving features bold designs with contemporary touches. From the woven facemasks of the *Chilkat Protector* series to the ceremonial *Fire Dish*, Hope's works teach us how to care for our community, be it past, present, or future. She carries this message a step further, teaching the skill to weavers all over the world. Hudson incorporates her weaving into high fashion ensembles that evoke the strength and resilience of Native women. Both Hope and Hudson grapple with the honor and burden of finding balance between custom and innovation. I first encountered Tlingit weavings during my time living in the Pacific Northwest. Such magnificent artworks deserve to be better known nationally.

Geo Neptune (Passamaquoddy) carries forward the honor and burden of being a master basket maker, following the legacy of their grandmother, Molly Neptune, who taught them the practice. Neptune weaves ash and sweetgrass baskets in complicated forms that radiate with ingenuity and personal significance. They use Passamaquoddy oral histories to create vibrant narrative pieces about their life as a two-spirit educator in Wabanaki communities in Maine. As one of only a few master basket makers in their community, Neptune considers it their duty to preserve the tradition and to pass it along to future generations.

Erica Lord (Athabascan/Iñupiat) creates dazzling beaded works that thoughtfully combine scientific data with the

customary forms of burden straps and sled dog blankets. Based on colorful DNA microarray assays, her designs highlight issues that disproportionally impact Native American communities, such as modern-day diseases including COVID-19, many of which are caused or exacerbated by poverty, healthcare inequity, and climate crises. At the same time, her works honor the history and culture of her hometown of Nenana, Alaska.

Maggie Thompson (Fond du Lac Ojibwe) creates poignant, personal installation work and socially engaged collaborative projects that aim to address complicated histories and build community. Through large-scale work, she brings form to relationships and grief. For the Renwick Invitational, artworks like *I Get Mad Because I Love You* and *The Equivocator* illustrate the lasting effects of unhealthy relationships, while her installation *On Loving* transforms mundane body bags into meaningful star quilts that honor loved ones who have passed. Ultimately, her works engage the burdens of grief and loss, reimagining and honoring them as things of beauty and healing.

It is a great honor to spotlight these artists. It is also a special burden of responsibility to showcase their artwork in a way that recognizes the past, present, and future. As visitors experience groundbreaking craft from makers across Alaska, Washington State, New Mexico, Minnesota, and Maine, we hope they will also walk away with a more nuanced understanding of how Indigenous perspectives and experiences are shaping American art today.

This exhibition, which directly follows the fiftieth anniversary of the Renwick Gallery's opening as the flagship museum of American craft, marks the tenth installment in the Renwick Invitational series. We are grateful for the generosity of Ryna and

Melvin Cohen, who have funded this series' existence since 2005. For the 2023 installation, we are particularly appreciative of additional significant support from several major US foundations, including The Andy Warhol Foundation for the Visual Arts, the Elizabeth Firestone Graham Foundation, Lannan Foundation, The Robert Lehman Foundation, the Windgate Foundation, and the Wyeth Foundation for American Art.

—**S.S.**

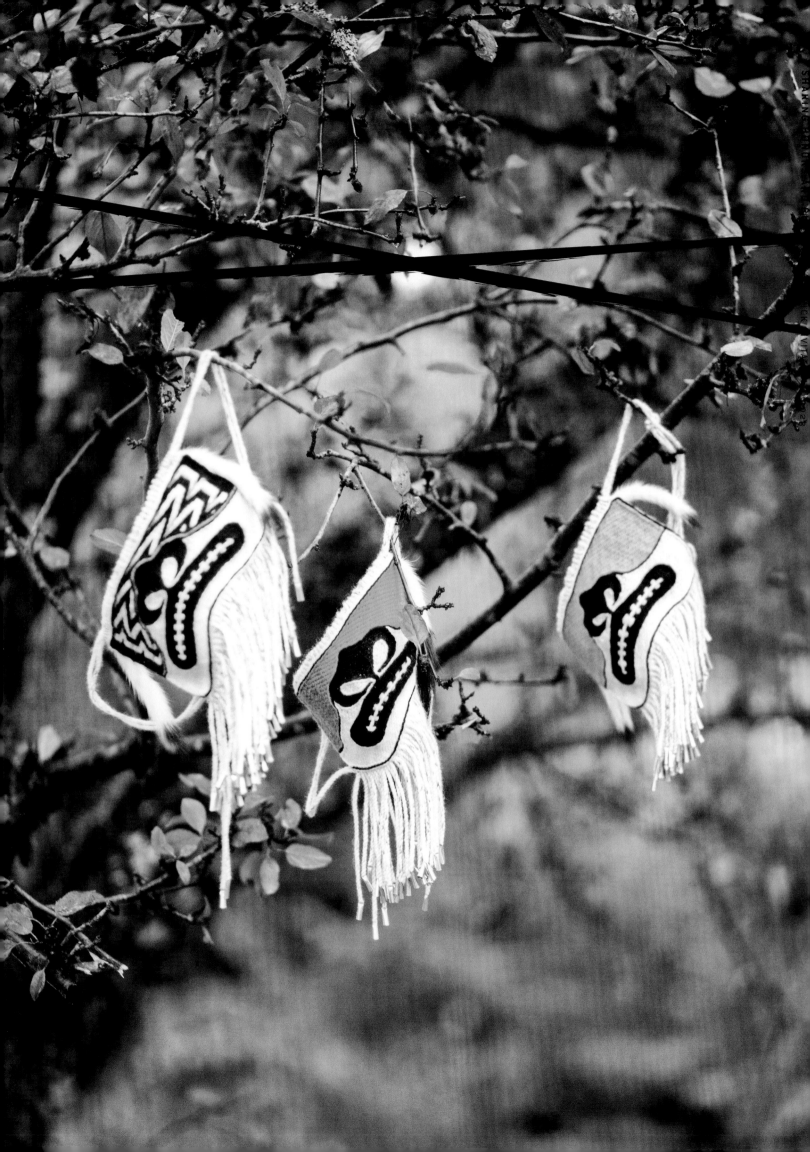

Lara M. Evans

Cherokee Nation

Acknowledgments

THIS EXHIBITION AND ACCOMPANYING publication involved the inspiration and commitment of many people. Ongoing support of Ryna and Melvin Cohen and the Cohen Family Foundation has been instrumental in stewarding the production of exhibitions and publications in the Renwick Invitational series. The lenders to the exhibition, institutional and private, also deserve recognition for their commitment to collecting and caring for the work of the artists in the exhibition.

Dr. Anya Montiel (Mexican/Tohono O'odham descent) deserves recognition for laying the groundwork for this exhibition. She is the former American Women's History Initiative–funded curator of American and Native American women's art and craft for the Renwick Gallery and is currently curator at the Smithsonian's National Museum of the American Indian. She organized the jurying process and chose Dr. Miranda Belarde-Lewis (Zuni/Tlingit) and me as jurors. The team at the Renwick Gallery and Smithsonian American Art Museum deserve praise for their enthusiastic support and thoughtful assistance. For their vision and commitment to diversity and equity, Stephanie Stebich, the Margaret and Terry Stent Director, and Nora Atkinson, the Fleur and Charles Bresler Curator-in-Charge, Renwick Gallery, deserve recognition. They guided the exhibition from its beginning to its execution. Organization and logistical support from Renwick and Smithsonian American Art Museum personnel was crucial to making everyday tasks possible while everyone largely worked remotely, even into the third year of the pandemic. Without the tireless work of collections manager Elana Hain, operations specialist Rebecca Sullesta, exhibition coordinators Erin Bryan

Lily Hope, *Woven Chilkat Protector Masks*, 2020
(see p. 48)

and Maia Worden, permissions coordinator Aubrey Vinson, administrative coordinator Kelly DeFilippis, and Christie Davis and Elizabeth Daoust in Development, we would not have an exhibition. The same may be said for exhibition designer Eunice Park Kim, graphic designer Nathaniel Phillips, production coordinator Adam Rice, and lighting designer Scott Rosenfeld, who honored the exhibition's works through their dedication to artful design. Carol Wilson and Kelly Skeen in Education and Interpretation also deserve recognition for their commitment to conveying the artists' messages to the public.

Before any artworks could be exhibited, shipping coordinator Austin McNellage, conservator Leah Bright, and registrars Jenni Lee and Cassandra Belliston made sure that they were handled, transported, and prepared for exhibition with care. For their roles in ensuring these artworks and artists receive the attention they deserve, I would also like to thank media and publicity contact Katie Hondorf, marketing coordinator Amy Hutchins, social media contact Amy Fox, special events coordinator Andrew Rondinone, and public programs coordinator Gloria Kenyon. Finally, for their dedication to crafting a catalogue that is a work of art in its own right, thanks go to managing editor Julianna White, editor Rosie Hammack, and book designer Denise Arnot.

The exhibition could not happen without the artists, of course. Their hands, hearts, and minds make the work. Producing new work for a major exhibition like this was made especially challenging by the pandemic. Shortages of materials and shipping caused too many challenges to count. These artists deserve to be honored for their perseverance. So much about their practice depends upon the knowledge and traditions of their cultural communities. The artists wish to acknowledge those who make their art possible:

Gunalchéesh from LILY HOPE and URSALA HUDSON to their teachers Jennie Thlunaut, Clarissa Rizal, and Bill Hudson; and their primary supporters Aunt Deanna and Aunt Irene J. Lampe, Kahlil Hudson, and Dr. Miranda Belarde-Lewis.

Gunalchéesh to Lily's creative collaborators and mentors: Alison Bremner, Kay Parker, Elijah Marks, Scott Burton, Sydney Akagi, Dr. Ellen Carrlee, Dr. Kathryn Bunn-Marcuse, and Dr. Zachary Jones.

Gunalchéesh to Ursala's creative support: Chris Haas, Amelie and Simone Haas, Adrienne Young, and Lorrie Andrews.

MAGGIE THOMPSON says *Miigwech* to her mentors and creative support: Tamara Aupaumut, Sage Phillips, Delaney Keshena, Jaida Grey Eagle, Tyler Steffenhagen, Peggy Thompson, Dyani White Hawk, Brad Menninga, Todd Bockley, Jill Ahlberg Yohe, Phoebe Young, Hannah Smith, Tyra Payer, Taylor Payer, and Hair and Nails.

ERICA LORD thanks the following for their creative support: Chelsea Bighorn, Joeseph Arnoux, Aubs Staats, William Wilson, Danyelle Means, Shannon Boyle, Princess Lucaj, Jeremy Mora, John Vokoun, Colleen Maki-Varney, Dana Varney, Mia Wenzel-Hill, Leroy Ramirez, Kat Griefen, Victor Lord, Vital Spaces, and the Ralph T. Coe Center for the Arts.

JOE FEDDERSEN thanks his friends, family, and mentors for their ongoing support and encouragement. Mentors include Robert Graves, Daryl Dietrich, Glen Alps, Vi Hilbert, Truman Lowe, Dean Meeker, and Jaune Quick-To-See Smith. Many friends include, to name a few—Anya Montiel, Corwin Clairmont, Ken Vander Stoep, Gail Tremblay, Lillian Pitt, Elizabeth Woody, Ron Carraher, and Feddersen's family, especially his nieces Carly Feddersen and RYAN! Feddersen, and nephew William Passmore.

GEO NEPTUNE wishes to acknowledge their teachers who have made the journey to be with the Ancestors. To Molly Neptune Parker, David Moses Bridges, Fred Tomah, Janet Neptune, and Deanna Francis: "Kci woliwon ciw kehkikemuwakonol naka koseltomuwakon."

And finally, $G\!\mathcal{V}$ (Wado), thank you, to my colleagues and the administration at the Institute of American Indian Arts and my spouse, Bobby Nowak, for their support of my work on this exhibition.

—L.M.E.

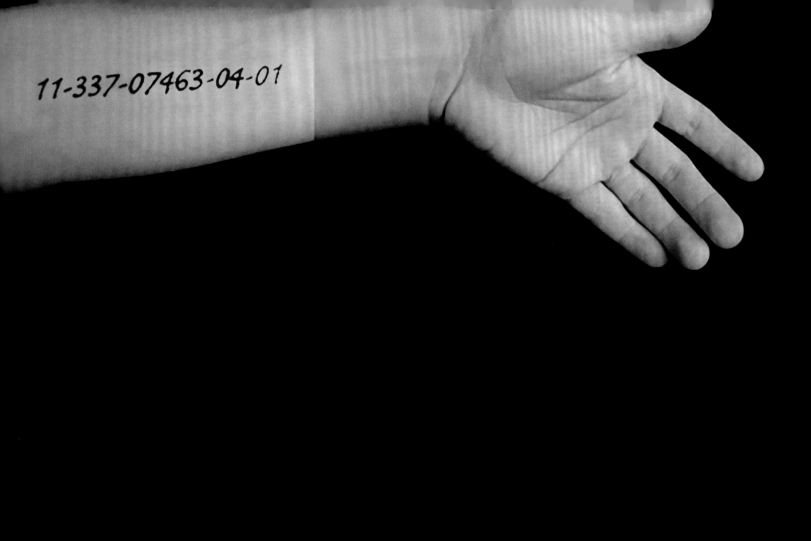

Lara M. Evans

Cherokee Nation

Introduction

WHAT DO WE CARRY WITH US, literally and metaphorically? How and why do we carry it? We can be burdened by grief, by our personal histories, and by history writ large. Yet some kinds of burdens can be precious to us. We carry them with love and pride and share them with each other. There is a tendency to think of "honors" as recognition bestowed on individuals by institutions, such as the military, schools and universities, or business entities. However, many of the works in this exhibition arise from traditions of making items that are essential to honoring family, community, moiety, or clan, and they require broad community practices. The works in *Sharing Honors and Burdens: Renwick Invitational 2023* help us think about honors and burdens through beautifully crafted artworks, large and small, in stillness and in movement.

The artists in this tenth installment of the Renwick Invitational were selected in the summer of 2021, when Dr. Anya Montiel (Mexican/Tohono O'odham descent), curator at the Smithsonian's National Museum of the American Indian, organized a jurying process with me and Miranda Belarde-Lewis (Zuni/Tlingit), the inaugural Joseph and Jill McKinstry Endowed Faculty Fellow in Native North American Indigenous Knowledge at the University of Washington's Information School. For the first time, the artists selected for the Renwick Invitational are all Native Americans and Alaska

Erica Lord, *Enrollment Number
(11–337–07463–04–01)*, 2007
(detail, see p. 71)

Natives. We considered many artists for this exhibition; there is a deep well of skilled, dedicated Native artists who deserve wider recognition. As we discussed our selections—Joe Feddersen (Arrow Lakes/Okanagan), sisters Lily Hope (Tlingit) and Ursala Hudson (Tlingit), Erica Lord (Athabascan/Iñupiat), Geo Neptune (Passamaquoddy), and Maggie Thompson (Fond du Lac Ojibwe)—we found our way toward two related themes that link these artists' practice and artwork: honors and burdens. Each artist uses traditional forms of making—weaving, beading, or sewing—and adapts the materials and techniques to create contemporary works of art. It is an honor to continue these traditions, but the artists also bear a burden of responsibility; they must constantly weigh the risks and benefits involved in adapting historical practices to new uses. The artworks themselves make tangible the range of honors and burdens we carry with us, from the grief and trauma of personal and community loss to precious knowledge gained from teachers and ancestors.

The place of Native American artists in the realm of American craft has always been tenuous. Except for a relatively brief association with the Arts and Crafts movement (1880–1920) in the context of an interior design element described as an "Indian Corner,"[1] work by Native artists has often been assigned to a separate ethnic craft category associated with tourism or with ethnographic interests, with few artists gaining acceptance within the world of fine art. The complicated histories of Native Americans and the incredible cultural diversity among the more than five hundred tribes of North America make it irresponsible to collapse them all into an easy relationship with craft art, especially if we are connecting them to American craft. After all, the artists presented in this Renwick Invitational are members of separate

sovereign Nations: Tlingit and Haida Tribes of Alaska, Nenana Native Association, Wabanaki Confederacy, Okanagan Nation, and Fond du Lac Band of Lake Superior Chippewa. Each artist works in some manner with techniques, materials, or concepts embedded within their tribe's customary practices and history, but they also intend their work to engage with global audiences and must deliberately navigate questions around which aspects are suitable to share with outside audiences and which are not. The works of many Native artists are conscious efforts to continue cultural values. Finding our way through deep histories and working out how we want to shape the future is a heavy responsibility that is both an honor and a burden.

In the United States, the population of Native Americans is relatively small, just under 3 percent of the national population, even with a substantial increase between the 2010 and 2020 census reports.[2] Statistical data about Native Americans involved in art and craft activities is quite limited, but data from a 2009 report by the First Peoples Fund estimated that 30 percent of Native Americans are "practicing or potential artists."[3] The report identifies the prevalence of practices of making in Native communities as crucial to the health and well-being of those communities, whether urban or rural.

Making is not only a form of self-expression but also a powerful way to process everyday life and express ties to community. Through making, an artist contributes to an expansive corpus of knowledge, often balancing customary functional forms with beauty and personal narrative. The inspirations for some of the works included in this Invitational are containers that literally hold, store, or carry important items. In their new iterations, customary materials, forms, and practices have been adapted

by the artists to speak to issues that particularly impact Native American communities. Erica Lord transforms DNA microarray analyses of common diseases into beaded burden straps. The most elaborate burden straps Lord's work references are a type used to carry babies, precious burdens each family is honored to carry, yet the floral and abstract geometric patterns have been replaced by the disease burdens caused by poverty and environmental damage. As we navigate a period marked by disease and unprecedented grief, Maggie Thompson turns body bags into beautiful tributes to those we have lost. Joe Feddersen's woven baskets and blown glass vessels are based on the twined cylindrical baskets used throughout the Plateau region to gather traditional foods. Geo Neptune's baskets, woven so intricately with striking colors and sculptural forms, serve as containers for narratives tying the mythological and philosophical values of Passamaquoddy traditions with contemporary lived experience. Lily Hope and Ursala Hudson's Northwest Coast weavings balance traditional and innovative techniques and represent both an honor and a responsibility for the wearers as well as the makers. The kinds of honors these artists reference carry responsibilities and obligations.

The continuation of craft traditions is a cherished responsibility. The art world at large expects artmaking to be a specialized activity practiced only by an elite few, but craft traditions depend on broader community participation, or they cease to be traditions. The artists in *Sharing Honors and Burdens* come from communities in which making is an honored way of coming to *know*. Making things for ourselves helps us understand abstract concepts and relationships. When people gather to learn weaving traditions, for example, social ties are formed and strengthened.

Working with materials from nature links the practitioners to the stewarding of natural resources. Anyone who endeavors to make their own items with skill and care is putting their hands, their mind, and their time into gaining knowledge and carrying that knowledge into the future. The artists of *Sharing Honors and Burdens* are deliberately making objects that evoke history, analyze the present moment, and bring cultural knowledge into the future. The burdens we carry are not always negative; some are chosen and held with pride and dedication. The honors are not simple celebratory recognitions of past achievements; they mark changes in responsibilities and shifting relationships. The making changes the maker. The sharing changes us all.

1 Baskets, textiles, and pottery by Native Americans were popular items for home decor in the early twentieth century. They could be purchased as a tourist activity, at a curio shop, or at a department store. For a history of the "Indian Corner," see Elizabeth Hutchinson, *The Indian Craze: Primitivism, Modernism, and Transculturation in American Art 1890–1915* (Durham, NC: Duke University Press, 2009).

2 "2020 Census: Native Population Increased by 86.5 Percent," *Indian Country Today*, August 13, 2021, https://indiancountrytoday.com/news/2020-census-native -population-increased-by-86-5-percent.

3 First Peoples Fund uses the term "potential artists" to describe those who have or are learning skills for making but are not presently earning income from this activity. See Marianne Shay, ed., *Establishing a Creative Economy: Art As an Economic Engine in Native Communities* (Rapid City, SD: First Peoples Fund, 2013), https://www.giarts.org /sites/default/files/Establishing-a-Creative-Economy_Art-Economic-Engine-Native -Communities.pdf.

JOE

FEDDERSEN

Anya Montiel

Mexican/Tohono O'odham descent

Seeing the World Anew

Fish Trap,
2021–22 (detail,
see pp. 38–39)

TO SPEND TIME WITH JOE FEDDERSEN is to see the world anew. He is an astute observer—he will notice a line of repeated triangles along a mountain range or a tiny, interlocking pattern within a QR code (**fig. 1.1**). Gathering inspiration from the world around him, he creates artworks that emphasize relationships among landscapes, animate beings, and the built environment. He does this, in part, through symbols discerned from the land, sky, and manufactured structures, from birds and fish to canoes and high-voltage towers (CATS. 1.1 and 1.2). His artworks, like those featured in the Renwick Invitational, also draw from his Native worldview as an Okanagan and Arrow Lakes person and his relationships with mentors and teachers whose lessons have sharpened his perception and strengthened his connection to homeland.

Feddersen was born and raised in Omak, a city in the traditional lands of the Okanagan in North Central Washington State. Located in a diverse topographical region of mountains, plateaus, valleys, lakes, and streams, Omak is also on the western border of the Colville Indian Reservation, of which Feddersen is an enrolled member.[1] He is the son of a Native mother and a German American father and the third of six

CAT. 1.1 *Tire*, 2003, blown and sand-blasted glass, 14 ½ × diam. 12 ¾ in., National Museum of the American Indian, Smithsonian Institution, Museum purchase from the artist, 26/2874

CAT. 1.2 *Horses and Deer*, 2020, blown and sandblasted glass, 13 ½ × 11 ¾ × 10 in., Smithsonian American Art Museum, Museum purchase through the Kenneth R. Trapp Acquisition Fund, 2021.34

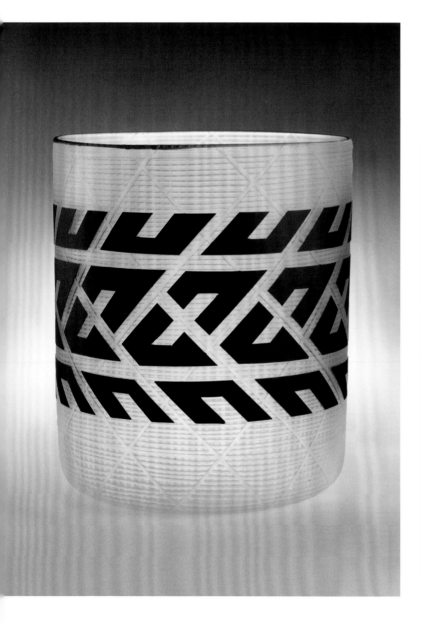

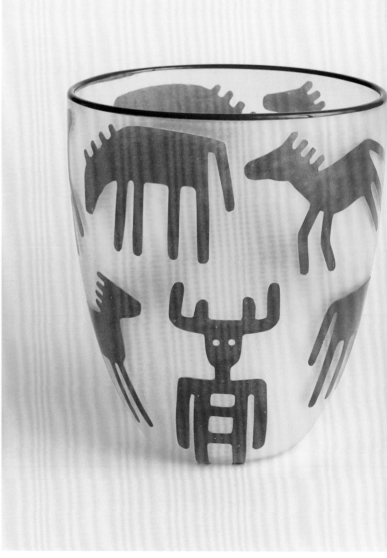

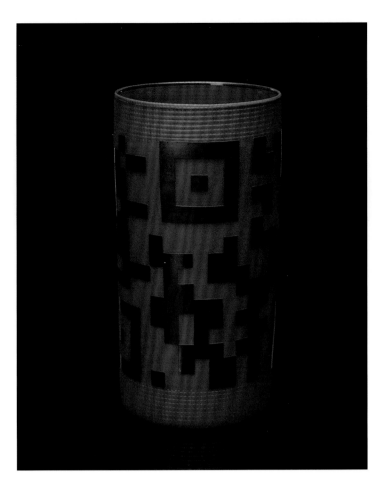

fig. 1.1 *QR Code*, 2012, blown and etched glass, 21 ½ × diam. 11 in., National Museum of the American Indian, Smithsonian Institution, Museum purchase, 26/9794

fig. 1.2 *Grandmother's Mountain*, 1992, relief print, 30 × 22 in., National Museum of the American Indian, Smithsonian Institution, Gift of R. E. Mansfield, 26/4326

children. During Feddersen's youth, he and his family would camp, hunt, and fish across the region and travel to visit his maternal relatives in British Columbia among the Penticton Indian Band of the Okanagan Valley.[2] These experiences instilled in Feddersen a deep connection to the area and imparted a love of the varied landscapes that constitute the Plateau region (fig. 1.2).

As a Native American artist who has been exhibiting and creating art since his youth, Feddersen understands the impact and perception of his work within his community and at large. His goal, he remarked, "is to create cultural assets for Plateau peoples, to contribute to *our* history. I want to do works that are of cultural significance and in the voice of my people."[3] While his art represents his vision and personal experiences, it also sits among other creative expressions by Native Plateau artists from time immemorial to the present day. For example, an Okanagan basket created a hundred years ago (fig. 1.3) continues to inspire the symbols and forms in Feddersen's art

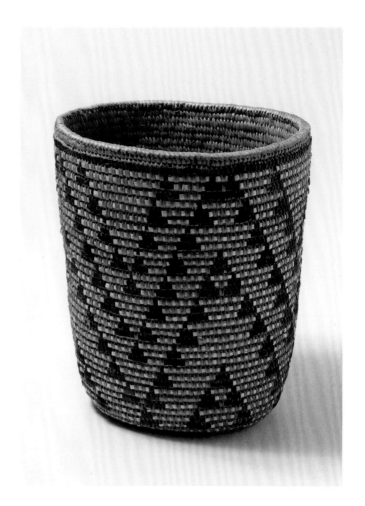

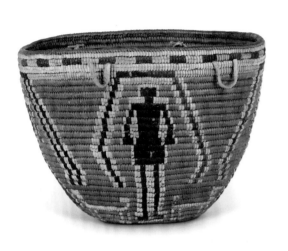

fig. 1.3 Unknown Salish (Thompson River) artist, Okanagan, *Gathering Basket*, ca. 1900, cedar, grasses, bark, and hide, overall: 9 ⅛ × diam. 12 ¾ in., Philbrook Museum of Art, Tulsa, OK, Gift of Yeffee Kimball, 1947.30.2

fig. 1.4 Elaine Timentwa Emerson (Methow/Okanagan), *Soripa Basket*, ca. 2005, cedar root, beargrass, and wild cherry bark, 10 ½ × 8 × 9 in., Collection of Joe Feddersen

(CATS. 1.3–1.5). From Colville weaver Elaine Timentwa Emerson (Methow/Okanagan, born 1941), he learned that the meanings behind a basket's design are specific to the tribe or community of its maker (fig. 1.4).[4] Emerson taught him that a design that represents the river in one area might represent something else to people on the other side of a mountain range. The artist's location and cultural context inform the artwork.

When considering how artworks, especially Native artworks, are viewed outside their cultural context, Feddersen commented, "It is a burden and an honor to represent your tribe."[5] He mentioned the television show *Grey's Anatomy*, where prints by Native artists have been used as set decor in the hospital. He said, "At first, I thought Native art broke into the mainstream. I saw works created by my friends. As time rolled on, it became apparent that the work was merely a backdrop."[6] The artwork hanging on the wall, Feddersen added, was voiceless and static. The television storylines never addressed the prints nor introduced the artists who made them. Non-Native artists often do

CAT. 1.3 *Roll Call*, 2021, twined
waxed linen, 7 ¾ × diam. 6 ¾ in.,
Private collection, Boston

CAT. 1.4 *Canoe Journey*, 2021,
twined waxed linen, 7 × diam. 5 in.,
Colville Tribal Museum, Confederated
Tribes of the Colville Reservation

CAT. 1.5 *Omak Stampede*, 2021,
twined waxed linen, 9 × diam. 6 in.,
Courtesy of the artist

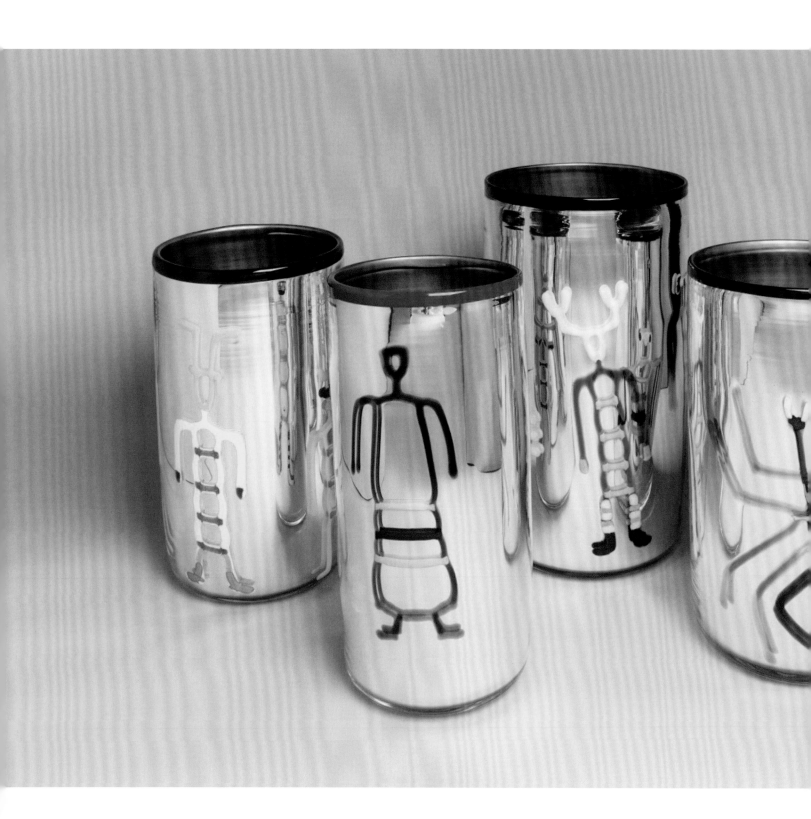

not understand the burden of representing one's tribal nation and *all* Native people in every artwork, exhibition, workshop, and public talk. Feddersen continued, "It is an honor to represent your community, your tribe, but it is also a burden to educate non-Native people about Native people. I want to contribute to my culture, not speak for all Native people."[7] Like the prints placed within the set of *Grey's Anatomy*, artworks lose any specificity or individuality when they must represent all Native people.

Feddersen's years of formal and informal arts education have connected him with teachers and mentors who have helped solidify his view on being an artist and artmaking. When he attended the Wenatchee Valley College in Washington State for his applied arts degree, he took courses from painter and printmaker Robert Graves (1929–2013). Through Graves, Feddersen met printmaker Glen Alps (1914–1996), with whom, among others, he went on to pursue a bachelor of fine arts at the University of Washington. Feddersen remembered an anecdote from Alps about a doctor instructing a patient to inhale and exhale on command and then "to breathe naturally."[8] Alps then related it to how one might approach artmaking, or, as explained by Feddersen, "to allow the work to flow naturally."[9] Feddersen, likewise, creates art from his surroundings and experiences and the work emerges therein.

The *Social Distancing* series of tall cylindrical mirrored glass vessels (CATS. 1.6–1.9) came about as Feddersen's response to the COVID-19 pandemic. As the series' title suggests, the colorful, abstracted human and animal (eagle, deer, and praying mantis) figures that Feddersen added around the exterior of the vessels are spaced apart: they do not touch. Having created the series during a residency at the Museum of Glass in spring 2021,

Feddersen working on
Charmed (Bestiary) (see p. 36)

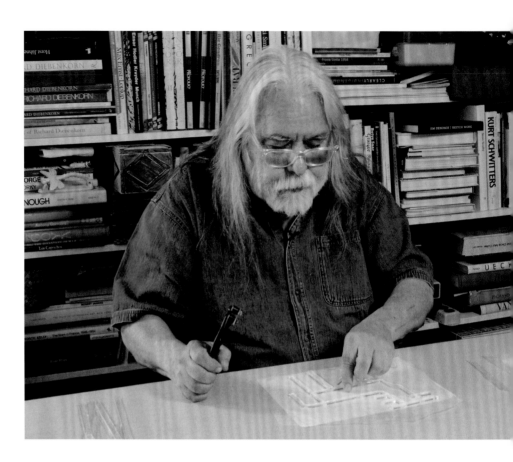

he told the museum's curator, Katie Buckingham, "In this case, we are in the middle of COVID, and social distancing has become part of our lives. I would like to relate that idea on some of the traditional basket forms. This is part of our life also. We are living through these times."[10] When viewers gaze into the vessels, their reflections become part of the work, and they see themselves as a part of the narrative. Like his ancestors and earlier artists, Feddersen is communicating through symbols and signs about lived experiences and current events.

Feddersen left Washington State to earn his master of fine arts at the University of Wisconsin–Madison, where he took courses in printmaking, computer graphic arts, glass casting, and painting while studying with professors Truman Lowe (Ho-Chunk, 1944–2019) and Dean Meeker (1920–2002). He returned to his home state in 1989 and joined the art faculty at the Evergreen State College in Olympia until his retirement in 2009. Feddersen then decided to return to Omak, telling journalist Bob Hicks,

CAT. 1.10 *Bestiary 5*, 2021,
monoprint, 44 x 30 in.,
Courtesy of the artist

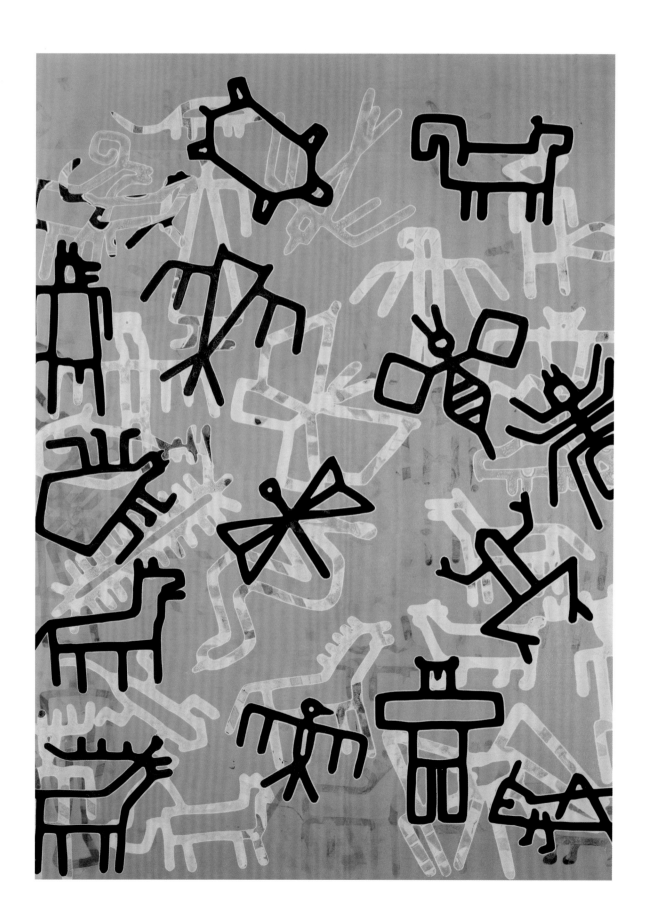

"Moving [home] gives me more time to do my artwork. But more important, it gets me back to my community."[11] Feddersen's love of his homeland has been steadfast; in 2017 he told curator heather ahtone (Chickasaw/Choctaw), "I'm just in awe of the landscape. I think of my relatives and how they would go up and down the valley all the time."[12] His large-scale work, *Charmed (Bestiary)* (CAT. 1.14), originated from one of his drives with his father around the Okanagan Valley. His father had remarked that the area was vacant and desolate. This depiction shocked Feddersen, because he saw a plentiful land with forests, shrubland, and waterways along with the bears, elk, fish, toads, and lizards that make their home there.

In response to his father's impression, Feddersen created *Charmed (Bestiary)*, a "glass line drawing" composed of hundreds of fused glass signs and symbols depicting human figures, animals, planes, biohazard signs, and the microscopic image of SARS-CoV-2 that hang like a curtain.[13] Like Feddersen's prints (CATS. 1.10–1.13), this work overflows with clever imagery, including a deer charm next to a stop sign. The charms and title hint at whimsical medieval bestiaries. Feddersen created the first *Charmed* glass work in 2012 for an exhibition on hybrid cultures at the Sun Valley Center for the Arts in Idaho.[14] He considered creating a charm bracelet, a wind chime, or a petroglyph wall for the exhibit; the final result is an aggregate of all three.[15] Like a charm bracelet, the work includes personalized symbols and signs, and, when a breeze blows, the glass figures clink and jingle against one another like wind chimes. When light shines on *Charmed*, the shadow from the glass figures creates images on the wall behind it, like a rock wall with overlapped petroglyphs. Like the biohazard symbols and high-voltage

CAT. 1.14 *Charmed (Bestiary)*
(detail), 2022–23, fused glass
and filament, approx.
120 × 180 × 10 in.,
Courtesy of the artist

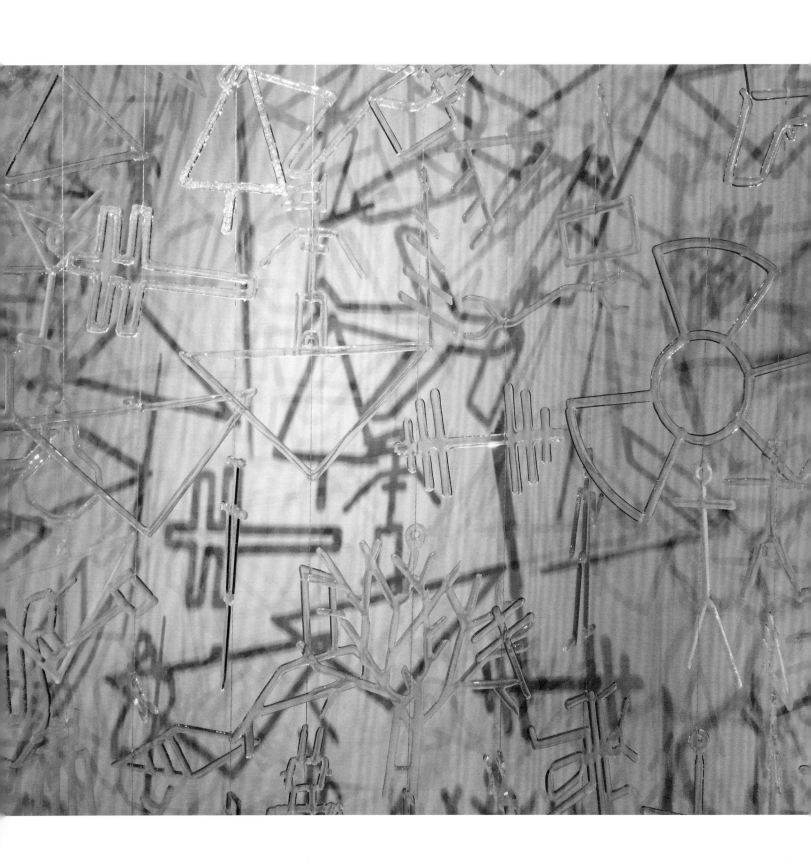

towers, some of the figures in *Charmed* incorporate contemporary iconography and signs that have become as commonplace as trees and birds in our daily lives.

Throughout his career, Feddersen has envisioned architectural design and geometric forms in everyday items. As he said to the Yellowstone Art Museum, "When I think of my work, it's about the world around me, and this takes a lot of different forms."[16] The glass work *Fish Trap* (CAT. 1.15) is based on a piece of fishing equipment used by many Native communities. While on a visit to the Salish Kootenai Community Center nearly twenty years ago, Feddersen noticed a willow fish trap on the wall. This fish trap was constructed in a slender, conical shape with one end having a radiating circle, or "mouth," meant to draw the fish inside. The other end is narrow and bound, preventing the fish from escaping (see fig. 1.5 on p. 40 for one example). In constructing his glass *Fish Trap*, Feddersen embellished it with multicolored glass rods, except for the circular opening, which he adorned with blue glass to draw the viewer in. Feddersen noted, "I was stunned by the beauty and the way this kind of technology of catching fish lent itself to the creation of such a beautiful and stunning object."[17] When hanging from the ceiling, the glass fish trap appears to be floating in suspended animation. While based on an ancient basket form and fishing equipment, Feddersen's *Fish Trap* celebrates the union between art and technology.

For the Renwick Invitational, Feddersen has brought together his glass works, prints, and woven baskets, demonstrating how his oeuvre spans multiple media to pair the best material with his vision. Scale is never an issue either; an artwork might stretch across an entire gallery wall or fit in the palm of one's hand. As

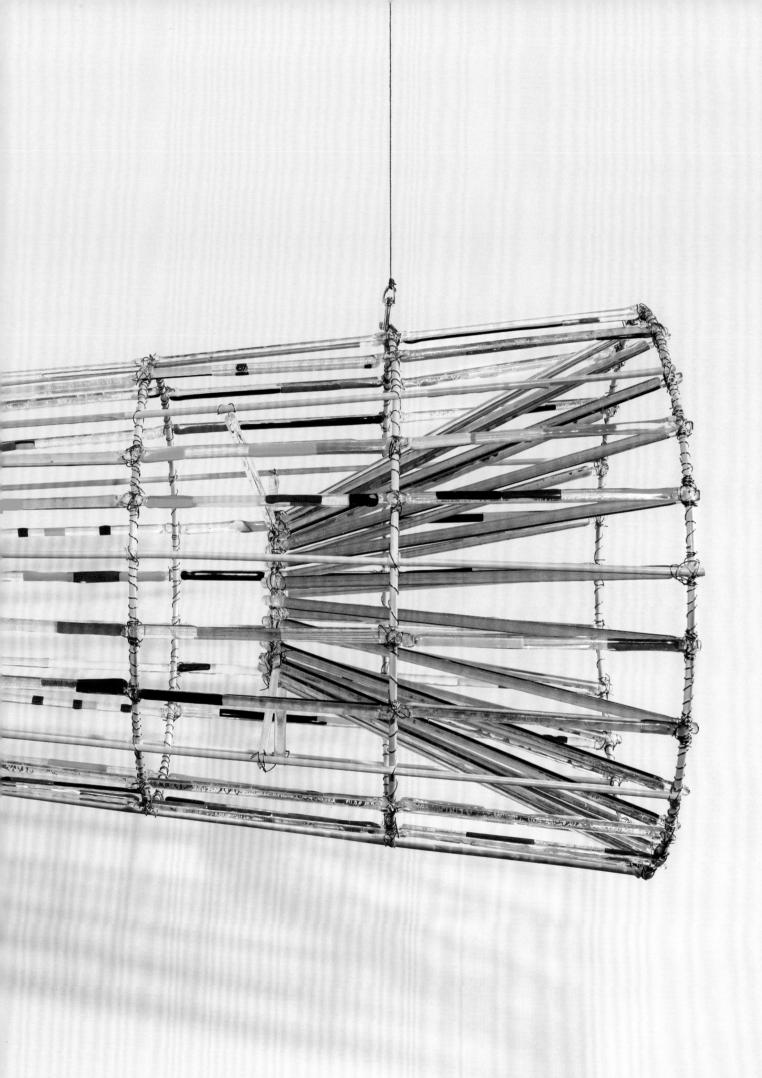

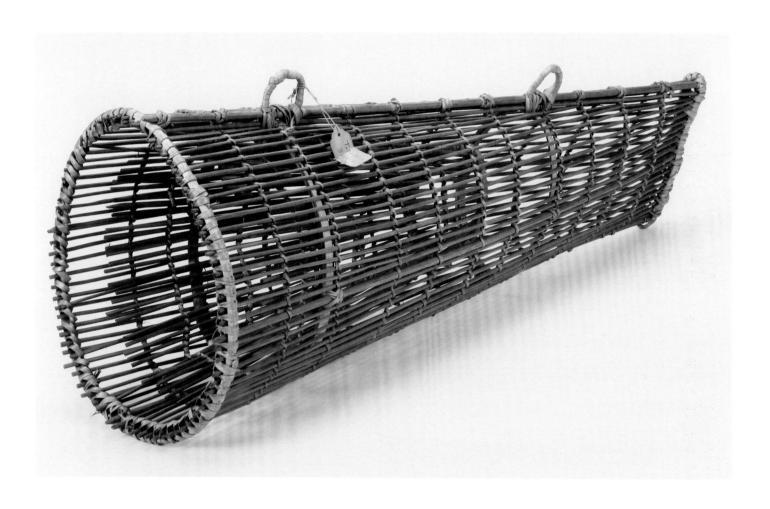

fig. 1.6 Tututni (Confederated Tribes of Siletz), Fish Trap, 1900–1910, wood and hazel, National Museum of the American Indian, Smithsonian Institution, 4/7528

both a student and a teacher, his keen observations and world-view fuel a creativity that continues to astound. Feddersen's longtime friend and fellow artist Elizabeth Woody (American Navajo/Warm Springs/Wasco/Yakama/Diné) might have said it best when she wrote that he possesses "an inheritance of visual integrity and traditional roots [that] fuels the emotional power of this focus, felt through each object."[18] Feddersen's art often acts as a palimpsest, drawing the viewer into the artwork and exposing the emotive layers and intersecting relationships that make one appreciate the world.

1 The Okanagan and Arrow Lakes Tribes are two of the twelve Colville Confederated Tribes.

2 Rebecca J. Dobkins, "Joe Feddersen: Pulses and Patterns," in *Joe Feddersen: Vital Signs* (Salem, OR: Hallie Ford Museum of Art; Seattle: University of Washington Press, 2008), 19.

3 Joe Feddersen, phone interview with the author, October 28, 2021.

4 heather ahtone, "Reading Beneath the Surface: Joe Feddersen's Parking Lot," *Wicazo Sa Review* 27, no. 1 (Spring 2012): 79.

5 Feddersen, phone interview, November 8, 2021.

6 Ibid., June 25, 2022.

7 Ibid., June 18, 2022.

8 Ibid., October 28, 2021.

9 Ibid.

10 Joe Feddersen, "What Are You Talking About? Conversation with Joe Feddersen," October 15, 2021, Museum of Glass, Facebook Live video, 31:30, https://www.facebook.com/watchlive/?ref=watch_permalink&v=1306659873104183.

11 Bob Hicks, "Exhibit of Joe Feddersen's Work at Hallie Ford Museum Shows He Straddles Several Worlds, All His Own," *Oregonian*, February 12, 2010, https://www.oregonlive.com/art/2010/02/exhibit_of_joe_feddersens_work.html.

12 heather ahtone, "Cultural Paradigms of Contemporary Indigenous Art: As Found in the Work of Shan Goshorn, Norman Akers, Marie Watt, and Joe Feddersen," (PhD diss., University of Oklahoma, 2018), 198.

13 Feddersen, phone interview, February 5, 2021.

14 *Crossing Cultures: Ethnicity in Contemporary America*, Sun Valley Center for the Arts (2012), exhibition brochure, https://issuucomsunvalleycenterforthearts/docs/crossing_cultures.

15 Feddersen, phone interview, April 18, 2022.

16 Feddersen, "I Refuse To Be Invisible: Joe Feddersen," July 15, 2021, Yellowstone Art Museum, YouTube video, 6:54, https://youtu.be/z6yyVlnhCkA.

17 Ibid.

18 Elizabeth Woody, "Joe Feddersen: Geometric Abstraction—the Language of the Land," in *Continuum: 12 Artists* (Washington, DC: National Museum of the American Indian, 2003).

JOE FEDDERSEN (Arrow Lakes/Okanagan; born Omak, WA, 1953; resides Omak, WA) grounds his vision in the confluence of twenty-first-century life and traditional Plateau crafts and culture. Through his glass works, twined baskets, and prints, he merges conventional patterns and contemporary iconography to reflect his lived experience of the land. He holds degrees in printmaking from the University of Washington and the University of Wisconsin–Madison. Feddersen spent much of his career balancing his art practice with teaching at the Evergreen State College in Olympia, Washington. After retiring from his full-time teaching position, he returned home to the Colville Confederated Tribal Reservation and now resides and works in his hometown of Omak, Washington. He remains a professor emeritus at the Evergreen State College.

Feddersen's works can be found in major collections across the country including the Smithsonian American Art Museum, the Whitney Museum of American Art, Eiteljorg Museum in Indianapolis, Seattle Art Museum, Portland Art Museum, Museum of Glass in Tacoma, and the Hallie Ford Museum of Art at Willamette University in Salem, Oregon. His work is also represented in print, including *Mixed Blessings* (2000) by Lucy Lippard, *Manifestations: New Native Art Criticism* (2012) by the Institute of American Indian Arts, Santa Fe, and *Changing Hands* (2005) by the Museum of Arts and Design, New York. The 2008 monogram, *Joe Feddersen: Vital Signs*, is part of the Jacob Lawrence book series from the University of Washington Press.

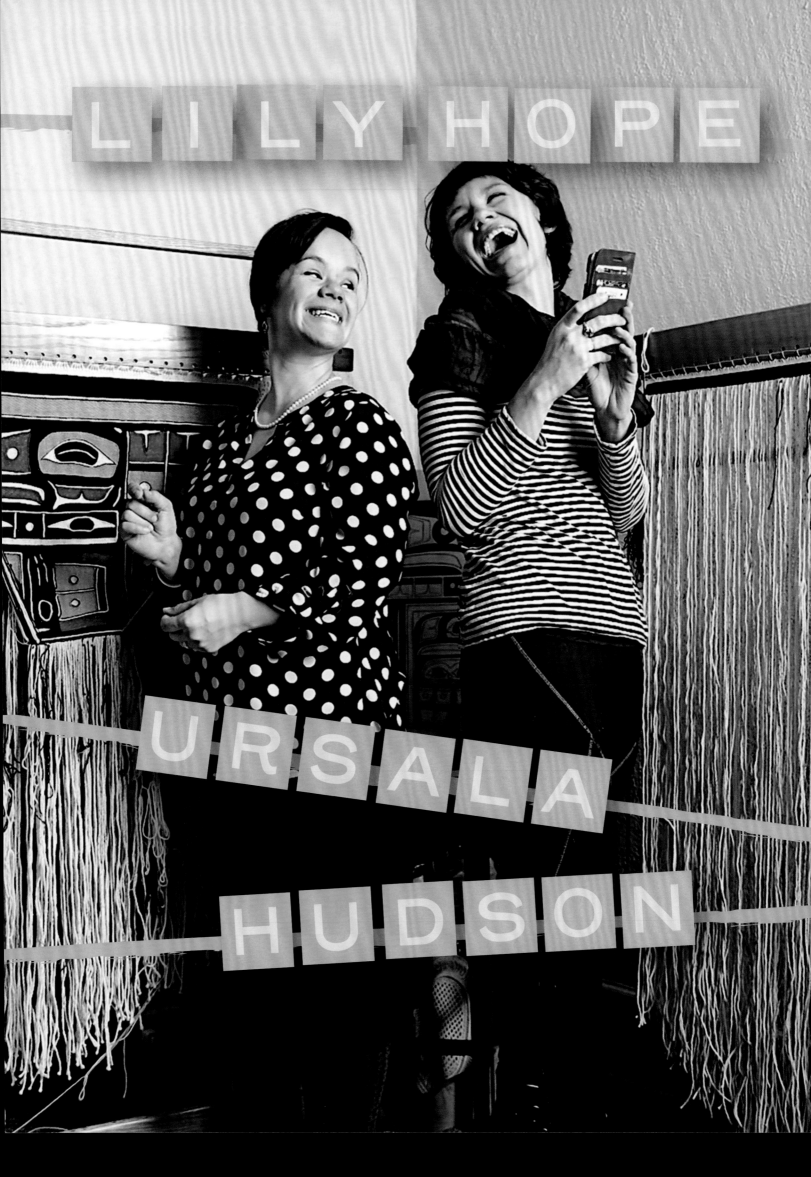

LILY HOPE

URSALA HUDSON

Miranda Shkík *Belarde-Lewis*
Zuni/Tlingit

Handwork Heartwork Artwork

THE CHILKAT AND RAVENSTAIL textiles that Lily Hope and Ursala Hudson weave are more than just artworks. Their weavings carry entire ways of Tlingit knowing. Hope and Hudson are artists, weavers, and sisters. As intergenerational recipients of Tlingit weaving knowledge transferred to them by their mother, renowned Chilkat weaver Clarissa Rizal (1956–2016), they create works that reflect clan relationships, gendered labor, and the Tlingit values of reciprocity and balance; their expert handwork provides a tiny window to view the relationship between Native peoples and the physical environment of the northern Northwest Coast. Hope and Hudson are reflections of the community relations required to maintain the practice of Chilkat and Ravenstail weaving, which they describe as their "heartwork"—their lives' purpose.

To explore these different facets of Hope and Hudson's weavings, this essay introduces their artwork featured in the Renwick Invitational, paying close attention to the handwork of each piece and the themes woven throughout. These themes are

Hope (left) and Hudson (right) in front of their work in progress

connected to the sisters' heartwork and include messages of care, strength, and resilience while balancing expectations of customary aesthetics and innovation. An excerpt of an interview I conducted with Hope and Hudson in the fall of 2021 follows.

fig. 2.1 Hope, *Between Worlds*
(adult robe), 2022, thigh-spun merino
and cedar bark, 49 × 74 × ¼ in.,
Houston Museum of Natural Science

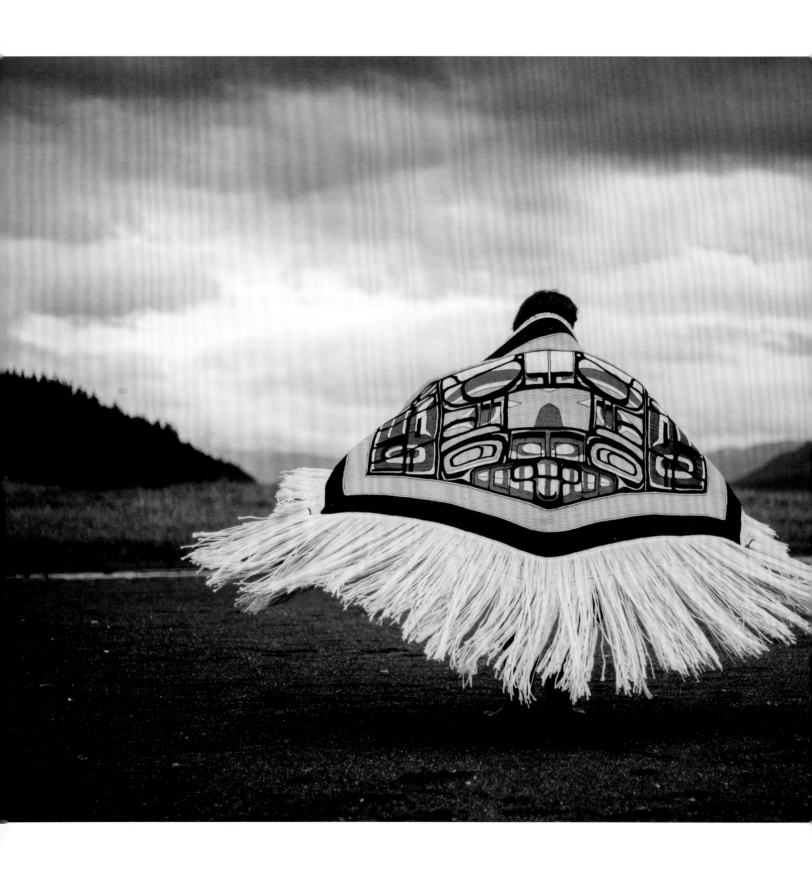

In the interview, the sisters describe, in their own words, the blessings and burdens of carrying Tlingit weaving forward as part of their heartwork.

Chilkat and Ravenstail textiles take hundreds of hours to make, and require years and years of training, research, perseverance, and dedication to master.[1] Every aspect of Chilkat and Ravenstail weaving is time consuming and the result of centuries of innovation.[2] Evidence of the incredible amount of handwork involved is present in every piece by Hope and Hudson.

Though the two forms of weaving may appear similar, Chilkat weavings can be identified through the use of formline[3] shapes and images that are distinct to northern Northwest Coast Native artwork, like those in Hope's robe *Between Worlds* (fig. 2.1). Ravenstail weavings tend to employ geometric designs, based on intricate mathematical patterns. Another way to distinguish between the two techniques is to identify the material of the warp, or the threads that run vertically through a weaving. At the risk of oversimplifying, Ravenstail warp generally contains mostly wool, while Chilkat warp is a blend of wool and cedar "threads," or strands of the inner cadmium layer of cedar bark. To create Chilkat warp, the cedar bark is boiled for hours to remove sap, separating the cedar fibers into thin, straight threads that are then added in proportionate amounts to wool as it is thigh spun from roving (the strand of fibers) into yarn. Thigh spinning relies on constant steady pressure and attention from the spinner, who uses their thigh as a workspace (fig. 2.2). The spinner presses their hand in a sliding motion down their thigh, mixing the cedar threads and wool roving together.[4] In doing so, they achieve the appropriate thread weight without the use of a spinning machine or wheel. Today, only a handful of weavers and fiber artists use the thigh spinning technique.

45

The "Z" spin that results from thigh spinning does not unravel when the weaver moves from left to right the way that commercially spun "S" strands of wool tend to do.[5] The cedar threads add stability to the top-hung, free-hanging Chilkat warp and provide the firm, sturdy base required to hold and support the "organized chaos"[6] that comprises the complex formline designs of Chilkat weaving. The pieces created by Hope and Hudson simultaneously reinforce and challenge these Tlingit weaving artforms.[7] They use this knowledge and skill to continue to innovate and adapt, bringing forth artwork that speaks to the past and future.

Lily Wooshkindein Da.Aat Hope

Lily Hope, whose Tlingit name is Wooshkindein Da.Aat,[8] uses these techniques to create artworks that are tied together through a message of care. Hope's works reflect the intensive heartwork at the center of her practice. The *Chilkat Protector* series of woven facemasks offers a way of caring for present-day kin, community, and future relatives, while *Between Worlds* and *Clarissa's Fire Dish* each touch on caring for ancestors through the tradition of Northwest Coast weaving technologies.

Upon the backdrop of the COVID-19 pandemic, Hope's *Chilkat Protector* mask series (CAT. 2.1) emphasizes our responsibility to care for one another during times of change and turmoil. Indigenous peoples have witnessed radical change many times over in the last five hundred years of Euro-American occupation. While Native communities have experienced disproportionate loss, sickness, and death during this pandemic, it is not a new position for us to be in to experience cataclysmic change within a lifetime. Hope acknowledges and documents

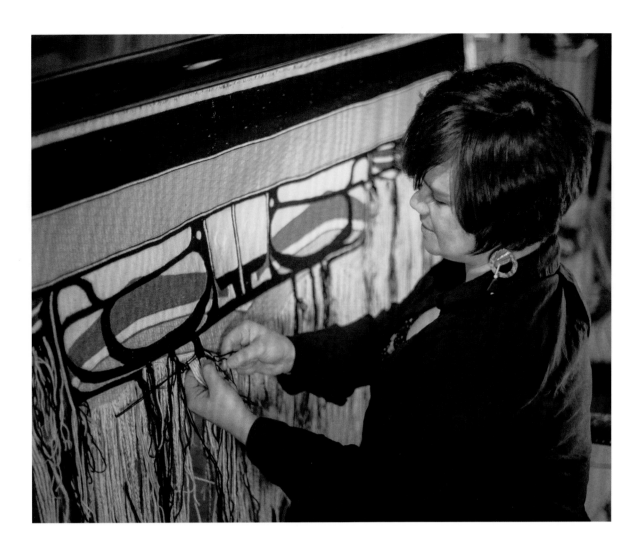

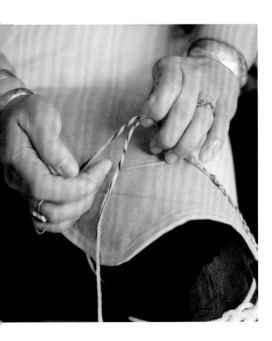

Hope weaving *Between Worlds*
(see p. 44)

fig. 2.2 Thigh spinning cedar fibers
and wool into yarn

this moment in global history while drawing attention to LGBTQIA+ awareness, ancestral Indigenous protectors, and the Black Lives Matter movement.[9] Hope regularly shares images of her protector masks on social media platforms. The masks are sometimes modeled by children—ambassadors of future generations and the ultimate reasons to be good citizens.

The *Chilkat Protector* masks are a blend of ancient, customary technology and the ubiquitous imagery of the COVID-19 era. Formline face designs regularly appear in Northwest Coast art forms. They are found in Chilkat weaving designs, carved masks, and totem poles; the style of the nose is as unique as the artist themself.[10] The isolation of the nose and mouth on these masks is an artistic innovation as well as documentation of our collective, shared experience of the pandemic. As Hope stated when awarded the 2020 Best in Show for the *In the Spirit* juried exhibition at the Washington State Historical Society, "*Chilkat Protector*

Hope, *Woven Chilkat Protector Masks*, 2020, thigh-spun merino and cedar bark with tin cones and ermine tails, three masks: 8 × 7 × 2 in. each, Anonymous and The Hope Family Trust

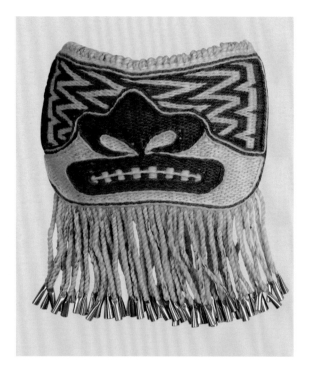
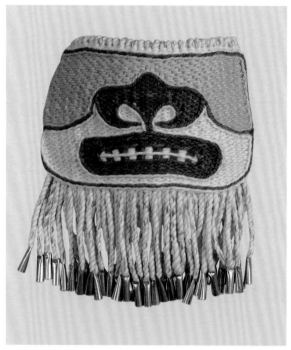
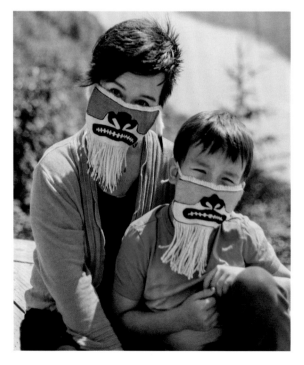
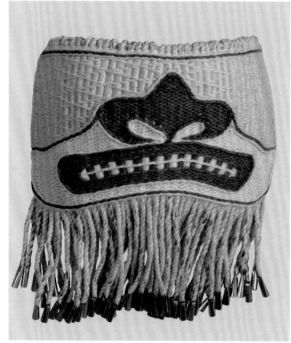

serves as a record of this time. In the future, people will know we were here, we took care of each other, and we survived."[11]

While Hope's pieces emphasize present-day challenges and the creation of lasting connections for future generations of weavers, they also honor ancestors, whether through the act of weaving, as in *Between Worlds,* or through a spiritual connection. The act of caring for ancestors after they have passed away is a widespread Indigenous practice. The *Between Worlds* robe is a departure from customary Chilkat weavings, with its bold out-lines between the design elements. The thick outlines create the faces of the ancestors, who gaze back at the weaver as the weaver gives them physical form, linking past, present, and future in the single act of creating a Chilkat textile.

The use of fire or smoke to carry the offerings of the physical world to the spirit realm is a Tlingit form of ancestor care. "Fire dishes," or *gankas'íx'i* in the Tlingit language, can take two forms, the first of which is a meal presented as gift or payment for being a witness at a *ku.éex̱* (memorial potlatch). The second form is a literal dish, made of carved or woven cedar and filled with food offerings. The food and the dish are ceremonially burned to feed relatives in the spirit realm, both recently and long-since passed.[12] With *Clarissa's Fire Dish* (CAT. 2.2), Hope has woven a Chilkat fire dish in honor of her and Hudson's late mother, Clarissa Rizal. Eventually, Hope intends to perform a ritual burning of this dish in tribute to the incredible life and work of Rizal, a prolific artist and weaver who is widely credited as being a cornerstone of the Northwest Coast textile weaving renaissance we find ourselves witnessing.

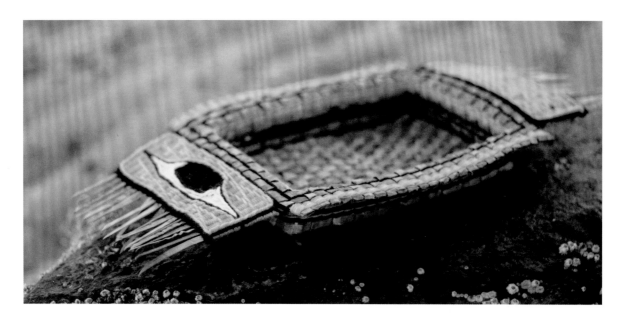

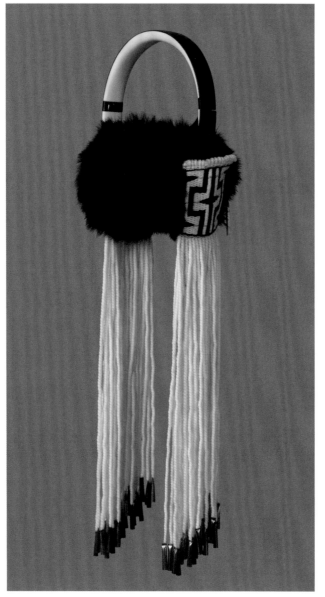

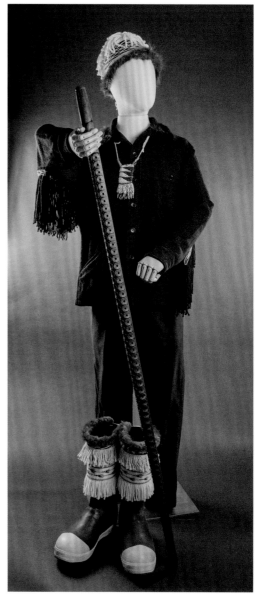

CAT. 2.2 Hope, *Clarissa's Fire Dish*, 2021, cedar bark and merino, 13 × 7 × 1 ½ in., The Hope Family Trust

CAT. 2.3 Hope, *Memorial Beats*, 2021, thigh-spun merino and cedar bark with copper, headphones, and audio files, 16 × 4 × 10 in., The Hope Family Trust

CAT. 2.4 Hope, *Tlingit CEO*, 2022, thigh-spun merino and cedar bark with copper cones, headdress and cane created by Eechdaa Dave Ketah (Tlingit), jacket: 44 in. long, boots: men's size 10 ½, The Hope Family Trust

CAT. 2.5 Hope, *Lineage Robe*, 2017, thigh-spun merino and cedar bark with beaver fur, 48 × 52 ½ × 2 in., Portland Art Museum, OR, Museum Purchase: Funds provided by bequest of Elizabeth Cole Butler by exchange

CAT. 2.6 Hope and Ricky Tagaban (Tlingit), *Double Raven Chilkat Dancing Blanket*, 2020, thigh-spun merino and cedar bark with fur, 51 × 54 × 2 in., Collection of Betsy Nathane

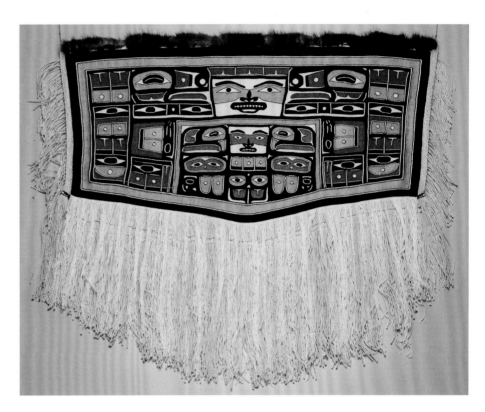

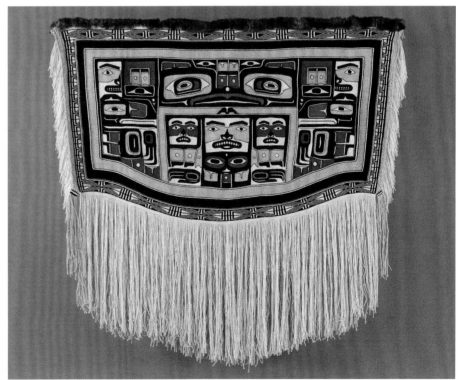

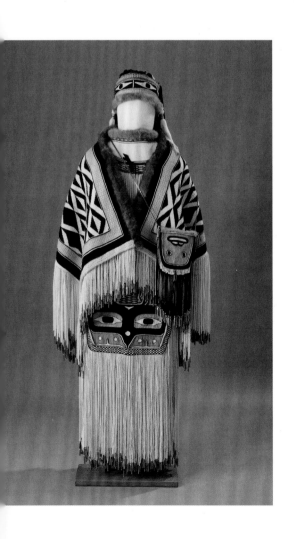

fig. 2.3 Clarissa Rizal, *Copper Woman* ensemble, including *Discovering the Angles of an Electrified Heart* robe, 2000, thigh-spun wool and cedar bark with mink fur, copper, brass, buckskin, and cotton cloth, Anchorage Museum of History and Art

Kadusné (Ursala Hudson)

The ensembles of Ravenstail regalia woven by Ursala Hudson, whose Tlingit name is Kadusné,[13] explore the delicate balance between custom and innovation. Each consists of several pieces, which can include a dance apron, a collar, a bodice, and sometimes a robe or cape. The ensembles have been adorned with woven accessories unique to each collection that can incorporate metal, shell, and feathers. The usual soft swing and sway of the lightweight Ravenstail fringe in each ensemble has been physically weighed down by the addition of cedar to the wool, as Hudson experiments swapping the customary wool warp threads with those usually employed in Chilkat weaving. The resulting mixture of Chilkat warp with Ravenstail designs has created a canvas ripe for innovation within the traditional "rules" of both styles of weaving.

Using this mixture of old and new technique and design, the *We Are the Ocean* ensemble (CAT. 2.7) honors feminine energy, maternal ancestors, and the water. The basket designs and twining used in the apron and shawl are visual and technical nods to the women cedar bark weavers. The high neck of the collar quietly exudes a high fashion editorial sensibility that acknowledges the non-Native influences on our everyday lives. Crochet finish work on the collar pays homage to grandmothers on both sides of the family and helps Hudson to engineer, and thus innovate, new woven forms that appear as natural as the tides.

The *Matriarch Rising* ensemble (CAT. 2.8) also honors and embraces fierce feminine forms of the past, present, and future. Twenty years after her mother graphed and wove the robe design *Discovering the Angles of an Electrified Heart* (fig. 2.3), Hudson worked the same design into the dance apron for *Matriarch Rising*.

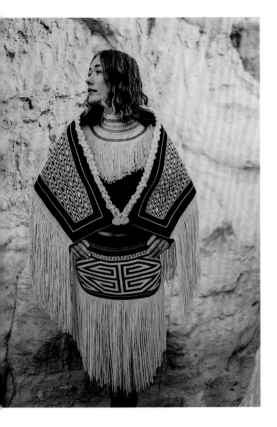
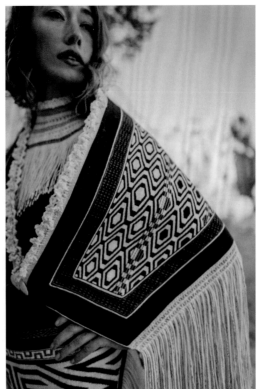
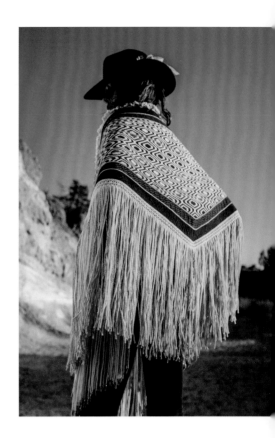

CAT. 2.7 Hudson, *We Are the Ocean*, 2021, collar: merino, silk, steel cones, and leather; *Woman as Wave* robe: thigh-spun merino and cedar bark with silk; *Tidal* apron: merino, silk, leather, steel cones, and Tencel, women's size 6, National Museum of the American Indian, Smithsonian Institution, Purchased with support from the Ford Foundation, 27/717

When reflecting on her adaption of the design, Hudson stated, "This is ceremonial regalia for the globalized yet indigenous-spirited warrior woman—her heart with the ancestors and her mind on the future."[14] The liberating nature of a dance apron (with significantly less woven weight than a robe) allows the wearer to move freely, as the modern Indigenous woman is expected and required to do. The entire ensemble responds to the needs of now, accentuating and embracing the wearer's feminine form as well as her strength. With their intricate beadwork and woven patterns, the hatband and earrings showcase the growing Indigenized beauty standards of our accessories, both outward and visible indicators of Native identity and present-day IYKYK[15] symbols of wealth. Identity and responsibility are woven into each piece of the ensemble. *Tideland Warrior* (CAT. 2.9) similarly invokes a high status. The ensemble honors those who require strength and those who are responsible for finding solutions. Deeply inspired by the enduring strength of the women in her own clan, Hudson engineered this hybrid of Chilkat and Ravenstail weaving with mountain goat–fur backing and a feather plumed headband. The green color of the outfit can be found in some older examples of both Ravenstail and Chilkat, but this

CAT. 2.8 Hudson, *Matriarch Rising*, 2021,
collar: merino, silk, steel cones, and leather;
Electrified Heart apron: merino, silk, leather,
and steel cones; hat: vintage wool hat, merino,
silk, and mother of pearl, women´s size 6,
Courtesy of the artist

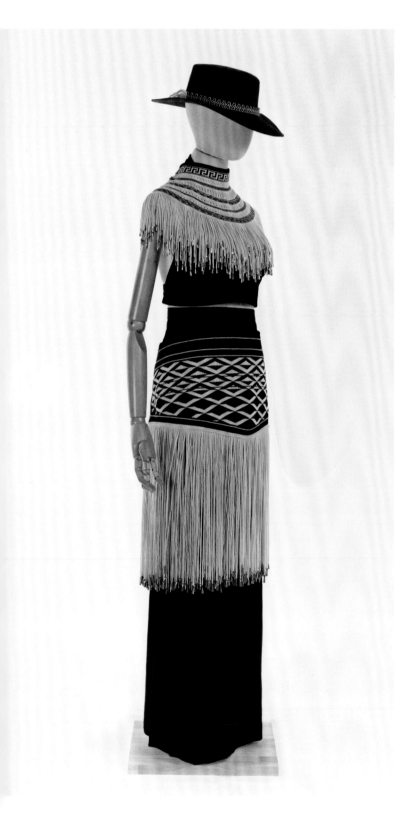

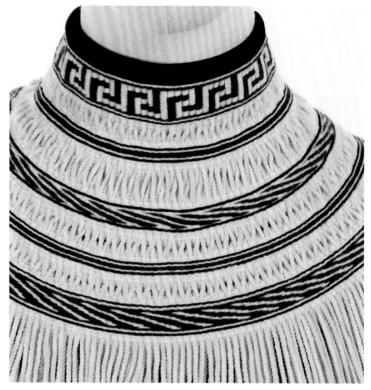

Hudson weaving *Sister Bear*

fig. 2.4 Template for Hudson's
Sister Bear, 2022

green is deeper, and personal; it is reminiscent of the ponderosa pine trees of Hudson's Colorado upbringing.

Hudson's first Chilkat robe, *Sister Bear*, also explores themes of feminine strength. The robe's design features a female bear (fig. 2.4), as signified by her labret, a piercing worn by women and girls in traditional Tlingit culture. The bear has reached an ancestral threshold. She holds the enormity of inherited experiences and knowledge from all her different bloodlines and carries this wisdom into a future that will look unlike any other.

As Hudson's first Chilkat robe, *Sister Bear* incorporates a signature shift from customary style to her own innovative twist, using black and white exclusively for the design and omitting the classic combination of yellows, greens, and black that has come to define Chilkat aesthetics. Just as the bear serves as an emblem of strength for women navigating an unknown future, the robe itself offers the same support to weavers, encouraging them to bend the rules just enough to remain true to the form while innovating with their own style.

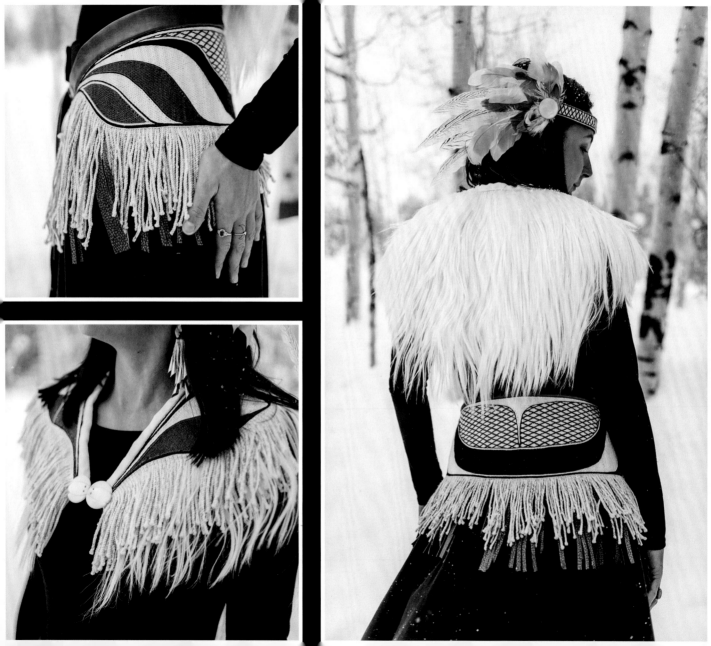

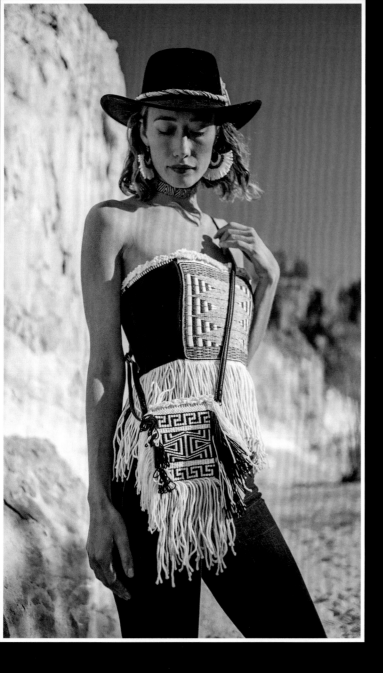
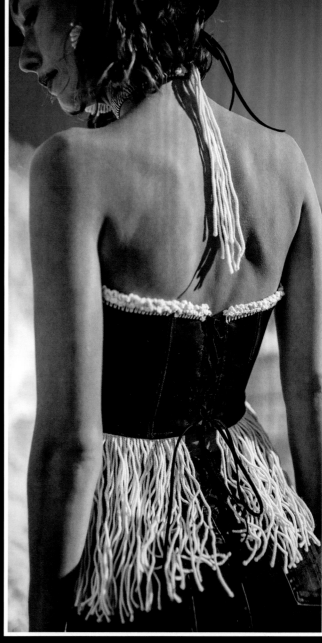

It is such a blessing to continue these
it's a blessing to get to see how they'r

IN THE FALL OF 2021, I sat down with Hope and Hudson
to discuss the joys and complexities of Tlingit weaving and how
the Renwick Invitational theme of "Honors and Burdens" reso-
nates with them. This exchange provides a firsthand account
between artists who also happen to be sisters. The Western
art-historical process rarely includes conversations between
artists, limiting our ability to learn how they regularly learn from,
influence, and challenge each other in pursuit of their art. The
interactions between artists are crucial to identifying themes,
not just of agreement but also of how individual artists within
a genre differ in opinion, style, process, and outcome. The sisters
generously provide a window into their thought processes and
what it means to be recipients of ancestral knowledge, to be
Tlingit weavers in the twenty-first century. Both sisters embrace
and honor the meticulous and labor-intensive forms of Chilkat
and Ravenstail and imbue the resulting pieces with their own
identities. Through their work, we as patrons, viewers, and fans
can relate to the collective struggles, strength, and resilience
they both display.

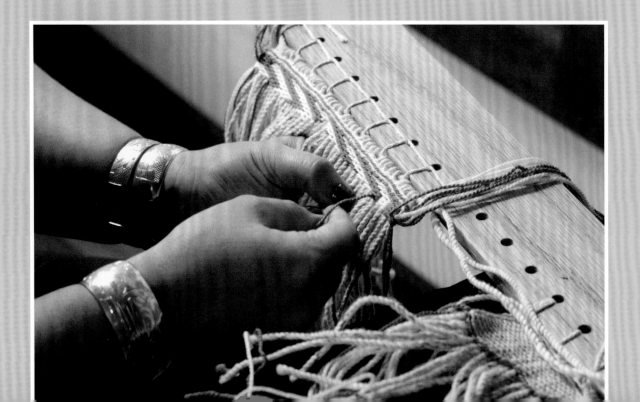

What do you want people to know about Ravenstail and Chilkat weaving?

HOPE I want them to know that they are current art forms...that they're woven every day. I want them to know the difference, the visual difference, between them. I want people across the world to be able to look at these two different textiles and say, "I know what that is. That is a Chilkat dancing blanket. I know where they're made. And I know that people are still making them. It is not a dead art form.... These are highly sought after, prestigious, collectible items that are still used in ceremony."

HUDSON I think Lily has some very specific, solid goals for sharing the knowledge of these art forms. But if I didn't know anything about it, [I'd want to know] that these are twined, how they're twined, and how long it takes. I'd like to know the traditional materials and also the modern materials and maybe why those have changed.

I think there's two different types of weavers. There's the weavers who are really into precision and creating the Chilkat or Ravenstail designs perfectly. And then there's those weavers that are, I think, doing it more for the ceremonial aspect and they're not as obsessed with the art of it. And so it is more of a craft. I'd like them to know that there are different types of weavers doing this for different reasons.

And the usage or the reason why someone would commission a weaving, or purchase a weaving, has changed. Our narrative as Indigenous communities is widening and growing and changing. And so the weavings don't mean what they used to.

HOPE There's a dual conversation happening.

Hope working at the loom

59

HUDSON This conversation right here ties perfectly into the blessings and burdens [theme] because it is such a blessing to continue these art forms traditionally. And it's a blessing to get to see how they're changing. And it's a burden to have to try to go back and adhere to the traditional teachings and traditional purpose of weaving these, and try to carry it forward in the right way.

HOPE It's not a burden to go back and weave them in the traditional way, as it is a burden to move forward while carrying the teachings with integrity. Whatever that forward looks like. So it's not a burden to do all the research and hold onto the teachings in the traditional way. It's a burden to hold space for those teachings and walk with integrity, and weave with integrity, aware of how hard our predecessors worked to retain the work, retain the teachings, as they were taught. So the burden is that constant balance of negotiating....How do we honor those teachings and still innovate?

That's a huge burden, especially thinking about all the different Tlingit art forms that have such a well-documented aesthetic tradition. If you're looking at the formline, then the proportions, the weights, the colors, the spacing — all of that is very well documented. It's a blessing that it's so well documented, right? It's also a burden because then when you try to move beyond that or expand it, then comes the community smack down...

HOPE ... of questioning how you think that fits in the canon of traditional Chilkat, or traditional Ravenstail, or traditional formline. And you kind of have to constantly be on your toes and justify every move you make.

top Hope working on a boot for *Tlingit CEO* (see p. 50)

center Model walking the runway wearing Hudson's *Tideland Warrior* (see p. 56)

bottom Detail of *Between Worlds* in progress (see p. 44)

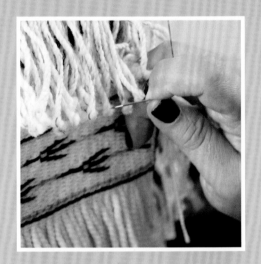

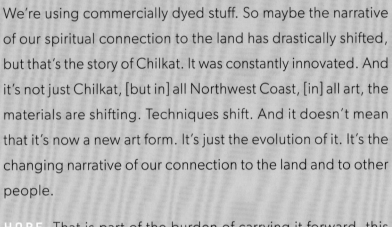

HUDSON And there you go. We're now using merino [wool]. We're using commercially dyed stuff. So maybe the narrative of our spiritual connection to the land has drastically shifted, but that's the story of Chilkat. It was constantly innovated. And it's not just Chilkat, [but in] all Northwest Coast, [in] all art, the materials are shifting. Techniques shift. And it doesn't mean that it's now a new art form. It's just the evolution of it. It's the changing narrative of our connection to the land and to other people.

HOPE That is part of the burden of carrying it forward, this sharing of that knowledge of the evolution. Just because it's purple doesn't mean it's not Chilkat. Because yeah, exactly as you said, if someone had done it two hundred years ago, if they had purple dye, they probably would've woven one. Or would they? Who do we ask?

What is it like to be a weaver?

HUDSON Glorious!

HOPE It is really nice to not have to question what my life work is. I guess that relates to what it's like being the daughter of a mentor, of a master weaver. Realizing that if I don't teach, who will? And because it seems to be my heartwork anyway.

It's a gift every day to be a weaver. I'm aware of that. It's a gift. To not have to think, well, what am I supposed to be doing with my life? What's my meaning? What's my life's purpose? Well, this is it.

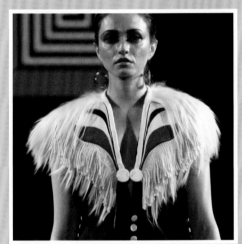

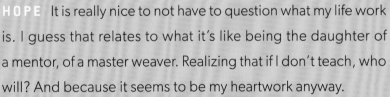

HUDSON That is a huge gift.

It's not a burden to go back and weav[e]
as it is a burden to move forward whil[e]
with integrity, for whatever that forw[ard]

HOPE Because we spend our whole lives going, why am I here? And maybe Ursala has a different take on this, but I'm not here necessarily to make work. I'm here to bear witness to it. I'm here to show up to the work that wants to become. And I'm here to make sure that there is someone who steps into my shoes as a weaver teacher when I pass into the spirit realm. So that is the trifold honor and burden of just particularly being a weaver.

HUDSON I just had this realization the other day. Not everyone is able to have the [physical] space and time [to weave] in their lives; they don't have the privilege. They don't have the skillset, . . . the history, the training to express themselves. And what I mean by [express] themselves is to express the doings of the universe, to express this creative energy that needs to come out. . . . Not everyone has that capability to tap into what needs to be expressed. And artists have that ability. It's my duty to try to make sure that I can continue doing that every day, on a consistent basis, expressing what needs to be made.

HOPE So much of the work is the surrender . . . when our will and our ego get in the way. The burden of surrender. . . . That we tend to flub up and make mediocre things . . . when my own will [is about] control, the way that I want it. When I'm in that state, my work is not at its best. And when I'm going to clear my mind and let this come be what it is, that's when the work seems to flow best.

I don't know if [our mother] Clarissa ever talked about the will as much as she talked about the ego. And I wonder how intertwined those are. Because I know that it's an absence of ego in the work. I mean the will to surrender, not the will to force a particular outcome. . . . What a curious difference.

them in the traditional way,
carrying the teachings
looks like. [Lily Hope]

HUDSON This actual surrender part takes so much preparation. You do have to have that will to set your life up and your day up to then surrender. You have to willingly put yourself in a super vulnerable spot to where you're willingly being like, I might screw up today because I'm just going with the flow. And that takes so much will that most people can't handle. They can't handle that vulnerability. So it takes will to surrender.

When you first asked, "what's it like to be a weaver," I was thinking about what it was like in comparison to being a different type of artist. And I was just having this thought the other day how relieving it is to be a weaver of a textile art form that takes so long to complete. It takes a lifetime of practicing your technique to get good at it. [It is] relieving...to be working in that art form compared to painting. Every time I'd do a painting, I'd be scared shitless that it wasn't going to be as good as my favorite piece. And I was constantly scared that I would never make good art again. But with weaving, before you even start, you're committing to making something so rad and phenomenal that all of that burden is gone. The reason why you're making the weaving is for reasons beyond art. Even if it doesn't look great, the intention and the spiritual energy and the background that brought you to that finished piece is so valuable that every weaving is going to be rad, whether it looks good or not.

HOPE What she said.

Hudson and Hope with their
mother, renowned weaver
Clarissa Rizal

HOPE AND HUDSON HONOR familial and tribally specific aesthetic practices while they innovate and adapt their brand of weaving. They are the beneficiaries of centuries of techno-logical innovation passed to them from their mother, master weaver Clarissa Rizal, who in turn received the technological skill from Jennie Thlunaut (1891–1986), and so on.

Hudson and Hope's handwork is helping to achieve their heartwork calling. As they continue to innovate within their art form, they contribute skill and artistry to a growing corpus of Chilkat and Ravenstail weaving, created by an increasing num-ber of weavers. The sisters have accepted and take strength from the essential challenge that accompanies their calling: to provide a path for their children and their community of weav-ers, toward a future that brings the strengths of our ancestors into our present, preparing us to step fully into our future as Tlingit peoples.

1 Chilkat weaving originated in the Pacific Northwest and is often used to create ceremonial robes (also called dancing blankets) worn by high-ranking members of the Haida, Tsimshian, Tlingit, and other Northwest Coast Indigenous Peoples of Alaska and western Canada. It is a finger-twined technique done on a loom with a top frame only, allowing the warp threads to hang freely. This allows the artist to create curvilinear forms within the weave. The textiles often have long fringe that sways when the wearer moves.

2 Miranda Belarde-Lewis, "Wearing the Wealth of the Land: Chilkat Robes and Their Con-nection to Place," in *Nature's Nation: American Art and Environment*, ed. Karl Kusserow and Alan C. Braddock (Princeton, NJ: Princeton University Art Museum, 2018).

3 Coined by Bill Holm, "formline" is an art-historical term used to describe the distinct artistic styles of northern Northwest Coast tribal communities. Holm developed a vocabulary to describe the individual elements present in masks, carved boxes, house fronts, totem poles, and all manner of items—a vocabulary widely adopted and still in use today. The terminology, which includes "ovoid," "trigon," "U-form," and "double U-form," is not without controversy and debate, but its widespread use by artists, scholars, and collectors proves its usefulness as a common lexicon. For the original analysis, see Bill Holm, *Northwest Coast Indian Art: An Analysis of Form* (Seattle: University of Washington Press, 1965).

4 Clarissa Rizal, *Jennie Weaves an Apprentice: A Chilkat Weaver's Handbook* (Juneau, AK: Artstream, 2005).

5 For further reading, see Cheryl Samuel, *The Chilkat Dancing Blanket* (Seattle: Pacific Search Press, 1982), Samuel and Ellen J. Lehman, *The Raven's Tail* (Vancouver: University of British Columbia Press, 1987), and Steve Henrikson et al., *The Spirit Wraps Around You: Northern Northwest Coast Native Textiles* (Juneau, AK: Friends of the Alaska State Library, Archives and Museum, 2021).

6 Sherry Taylor, "Lily Hope: Tlingit Weaver of Chilkat and Ravenstail," *Handwoven*, September/ October 2020, https://handwovenmagazine.com /lily-hope-tlingit-weaver-of-chilkat-and-ravenstail/.

7 For more on the steadily increasing number of Ravenstail weavers, see Steve Henrikson, "Yéil Koowú: The Reemergence of Ravenstail Weaving on the Northwest Coast," *American Indian Art Magazine* 18, no. 1 (1992): 58, and to view weaving in the larger context of Northwest Coast arts, see Kathryn B. Bunn-Marcuse and Aldona Jonaitis, *Unsettling Native Art Histories on the Northwest Coast* (Seattle: Bill Holm Center for the Study of Northwest Native Art, Burke Museum, in association with University of Washington Press, 2020).

8 Wooshkindein Da.Aat is Hope's Tlingit name, given to her by her maternal family in Alaska.

9 Amy Fletcher, "Lily Hope: Tlingit Weaver," *First American Art Magazine*, no. 30 (Spring 2021): 48–53.

10 Clarissa Rizal, personal communication with the author, August 2016.

11 Lily Hope, "Lily Hope: Chilkat Protector Mask," August 6, 2020, Washington State Historical Society, YouTube video, https://www.youtube. com/watch?v=qh0I46qtJUc.

12 See "Artist Nicholas Galanin Selected for Native Burial Ground Monument," City of the Borough of Juneau, February 14, 2018, https:// juneau.org/newsroom-item/artist-nicholas-galanin -selected-for-native-burial-ground-monument.

13 Kadusné is Hudson's Tlingit name, given to her by her maternal family in Alaska.

14 Hudson, "Matriarch Rising [Ensemble]: Inheriting the Angles of an Electrified Heart," Kadusné (artist's website), accessed August 15, 2022, http://kadusne.com/works/matriarch -rising-ensemble/.

15 IYKYK is text and internet slang for "if you know, you know," indicating an emic or insider knowledge.

LILY HOPE / WOOSHKINDEIN DA.AAT (Tlingit; born Juneau, AK, 1980; resides Douglas, AK) is of the Raven moiety, belonging to her grandmother's clan, the T'akdeintaan. She learned Ravenstail weaving from her mother, master weaver Clarissa Rizal, and artist Kay Field Parker. She apprenticed for over a decade in Chilkat weaving with Rizal who, until her untimely passing in 2016, was one of the last living apprentices of the late master Chilkat weaver Jennie Thlunaut. Hope endeavors to leave honorable weavers in her place.

Hope is one of few living designers of ceremonial dancing blankets, flowing garments created and worn by northern Northwest Coast Alaska Native peoples. Her contemporary works in textile and paper collage weave together Ravenstail and Chilkat design. She teaches both finger-twined styles extensively in person (and virtually since COVID-19) in the Yukon Territory, down the coast of Southeast Alaska, and in Washington and Oregon. She demonstrates internationally and offers lectures on the spiritual commitments of being a weaver. She also teaches Career Development for the Artist, supporting and encouraging artists to thrive and live well.

Hope constantly looks for ways to collaborate with other artists, often spearheading multicommunity projects or managing huge campaigns, like the *Giving Strength* robe for AWARE, a domestic violence shelter, and the *PRIDE Robe* woven with LGBTQIA+ youth at Zach Gordon Youth Center in Juneau. Her work can be found in numerous museum collections, including the Portland Art Museum, Houston Museum of Natural Science, Museum of Man and Nature in Germany, Eiteljorg Museum in Indianapolis, Burke Museum of Natural History and Culture, and the Sealaska Heritage Institute.

URSALA HUDSON / KADUSNÉ Like her sister, Ursala Hudson (Tlingit; born Santa Fe, NM, 1987; resides Pagosa Springs, CO) is of Caucasian, Filipino, and Alaska Native descent. Drawing from decades of experience in graphic design, Hudson crafts woven Tlingit couture with innovative designs that break from traditional Chilkat and Ravenstail styles of weaving. Her intricate garments subvert conventional thinking, blurring the lines between custom and high fashion and elevating the strength, beauty, and resilience of the women who wear them. Combining tradition and modernity, her ensembles tell the present-day, evolving story of her people and the land of the Pacific Northwest Coast.

Although she was raised immersed in the art business and practice of her mother, renowned weaver Clarissa Rizal, it took Hudson twenty-nine years to complete her first weaving—just months prior to her mother's passing in 2016. Her sister, Lily Hope, has mentored Hudson through relearning the process. After completing her first full ensemble in the spring of 2021, Hudson was granted a LIFT fellowship from the Native Arts and Cultures Foundation, won Best of Show at the Washington State History Museum's *IN THE SPIRIT* exhibition, and is a 2022 fellow of the First Peoples Fund's Artist in Business Leadership Program. She has won numerous awards at the Sealaska Heritage Institute's biennial Juried Art Shows and was a recipient of a Bill Holm Research Residency grant. Her work walked the runway during the Indigenous Fashion Arts Festival 2022, the 2022 Adäka fashion show in Whitehorse, Yukon Territory, Canada, and the 2022 SWAIA Gala haute couture fashion show in Santa Fe. Her work has been included in multiple recent exhibitions, including the Center for Contemporary Arts in Santa Fe and a duo show with her sister at Stonington Gallery in Seattle in 2022.

Lara M. Evans

Cherokee Nation

Coded Burdens
Coded Honors

Adrenocortical Cancer Burden Strap, 2021–22 (detail, see pp. 74–75)

ON VISITS TO HER NEIGHBORHOOD dog park in Santa Fe, Erica Lord surreptitiously snaps photos of dog breeds used as sled dogs. They remind her of her childhood in Nenana, a Tanana Athabascan village in the interior of Alaska. Keeping sled dogs was a family affair, and her memories of their pack of thirty to forty Malamute-Husky dogs are among her earliest and happiest. Lord's installation in the Renwick Invitational, *The Codes We Carry*, is an outgrowth of her relationship with sled dogs. It is a formation of abstracted sled dogs that wear beaded tuppies (dog blankets) and are harnessed to a sled. By transforming the trappings used with sled dogs, Lord illuminates the cooperative and intimate relationships between humans and animals working in careful balance for survival in the harshest of conditions. The installation also touches upon disease, contagion, and genetics, themes Lord has periodically explored over the past decade with a series of works based on burden straps. In her community, woven or decorated hide straps are traditionally used to carry babies or heavy bundles. Lord reconfigured this technologically simple carrying device with materials and patterns representing diseases and conditions that particularly affect Native Alaskans today. Her transformation of customary burden straps and tuppies

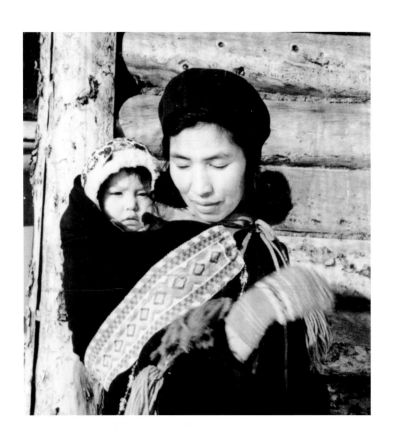

fig. 3.1 A woman uses a baby belt
to carry her child, Fort Yukon, 1940.
Alaska State Library, Evelyn Butler and
George Dale Collection, George A.
Dale, P306-0174

reflects the invisible and intangible things we carry: from love and pride in family and community to the burdens of historical trauma, colonialism, poverty, pollution, and environmental change.

Lord has worked in many media. Her master of fine arts from the School of the Art Institute of Chicago focused on sculpture, photography, and video. She is physically present in much of her photographic and video installation work. Her well-known early works include her presence as the photographer,[1] as in the *Un/Defined Self-Portrait* series from 2005, which plays with the malleability and performativity of racial ambiguity.[2] In 2008, Lord transitioned from performing for the camera to live performance art with *Artifact Piece, Revisited*, in which she performed her own version of James Luna's *The Artifact Piece* (1987/1990),[3] with Luna's permission and assistance. Concurrently, she began her work with burden straps. Functional burden straps cross over the torso to carry a bundle at the front or back of the body, keeping the hands free. The kind used to carry babies and toddlers are ornately decorated (fig. 3.1). Lord's burden straps are not functional but rather serve to explore complex themes related to Lord's experience as a Native Alaskan artist. In 2005, Lord created *My First Baby Belt* (fig. 3.2),[4] a work that explores blood quantum measurements.

Made from moose skin and embellished with beads, ribbons, and embroidered red cursive text, this strap poses the question,

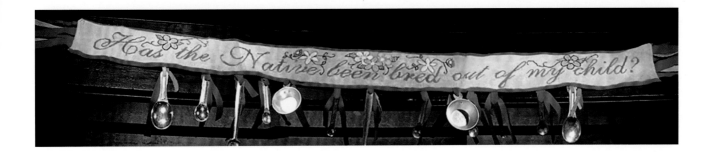

fig. 3.2 *My First Baby Belt*, 2005–7, moose skin, glass beads, wool, and metal measuring cups and spoons, approx. 12 × 72 × 1 in., Courtesy of the artist

"Has the Native been bred out of my child?" Measuring cups and spoons dangle from its lower edge, ready to measure the fractions of Native "blood" remaining. Lord's father is Athabascan/Iñupiat and her mother is Finnish American. If Lord were to have a child with a non-Native or a Native from another tribe, that child would not be recognized legally as Native Alaskan because their percentage of "Indian blood" would drop below a quarter.[5] Other works of Lord's have addressed issues around mixed-race identity and blood quantum issues. The series *Tattooed Arms* (CATS. 3.1 and 3.2) is composed of two life-sized photographs of the artist's arms, pieced together from multiple exposures, with the fractional formula representing her blood quantum on one arm and her tribal enrollment number on the other. The dehumanizing numbers inscribed on her body draw immediate parallels to the Nazis' use of numerical tattoos in concentration camps.[6] Through focusing on the surface of the body, Lord's early performative and photographic works call into question the legitimacy of racial identification.

The DNA microarray patterns used in the later burden straps and the installation *The Codes We Carry* move us to a microscopic and technologically mediated view of the body. Since beginning her work with burden straps in 2005, Lord has been exploring abstracted images from genetic testing combined

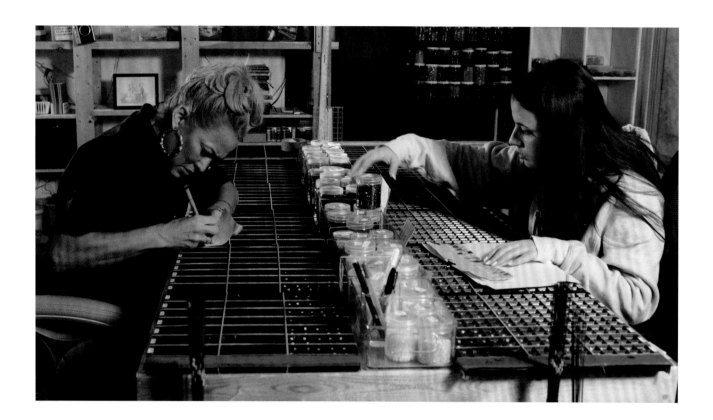

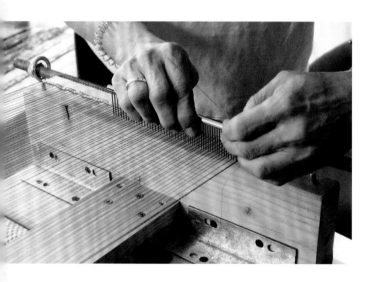

fig. 3.3 Lord and her assistant sorting beads at a grid table

fig. 3.4 Lord working at the loom

with burden strap and tuppie forms. The DNA-based straps and blankets are not "operational," as she has selected the materials for their beauty rather than for function. Her starting point was the colored geometric shapes produced by DNA microarray assays.[7] These genetic analysis tools produce color-coded, spatially arranged representations of specific features in DNA strands. There are many kinds of microarrays with a wide range of uses. They can help identify the presence of specific diseases, gene expressions, mutations, pathogens, and more, and are useful in forensic analysis and in identifying drug candidates. Some microarrays make patterns that are long and narrow, reminiscent of the dimensions of baby belts and burden straps. When designing a burden strap, Lord enlarges the microarray to create a pattern board with assigned bead colors. In Lord's patterns, each four millimeter–square glass bead correlates proportionately to one segment of genetic code (**figs. 3.3** and **3.4**). These beads can serve a one-to-one ratio to the microarray patterns or

CATS. **3.1** and **3.2** *Enrollment Number (11–337–07463–04–01)* and *Blood Quantum (1/4 + 1/16 = 5/16)*, from the series *Tattooed Arms*, 2007, inkjet print, 14 × 40 in. each, Courtesy of the artist

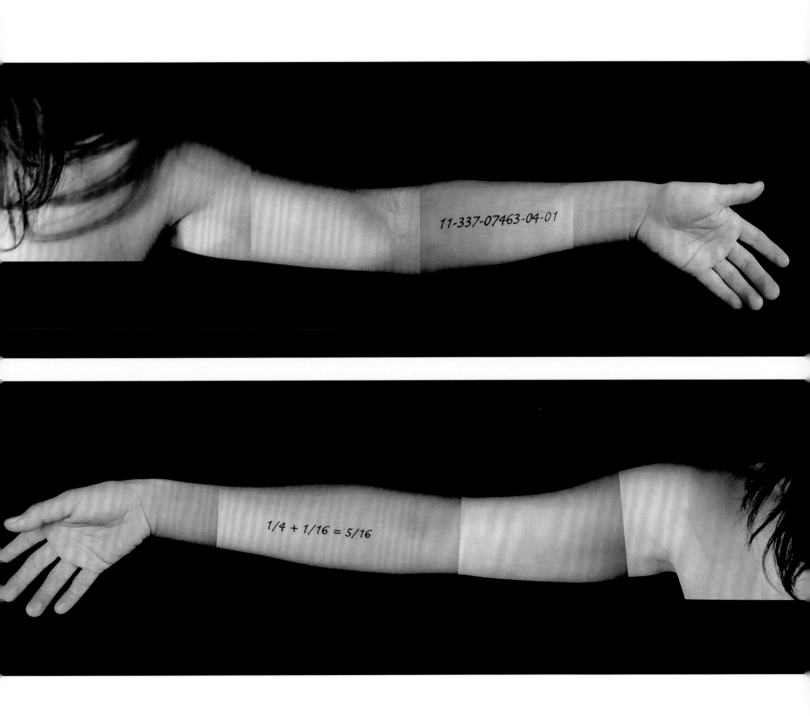

CAT. 3.3 *Diabetes Burden Strap, DNA/RNA Microarray Analysis*, 2008, glass beads and wire, 4 × 55 ½ × 1 ¼ in., Municipality of Anchorage, AK | Public Art Program

CAT. 3.4 *Leukemia Burden Strap, DNA/RNA Microarray Analysis*, 2022, glass beads and wire, 7 ½ × 94 ½ × ¼ in., Courtesy of the artist

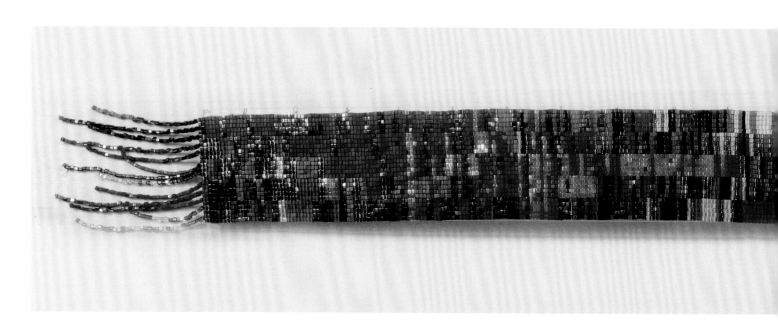

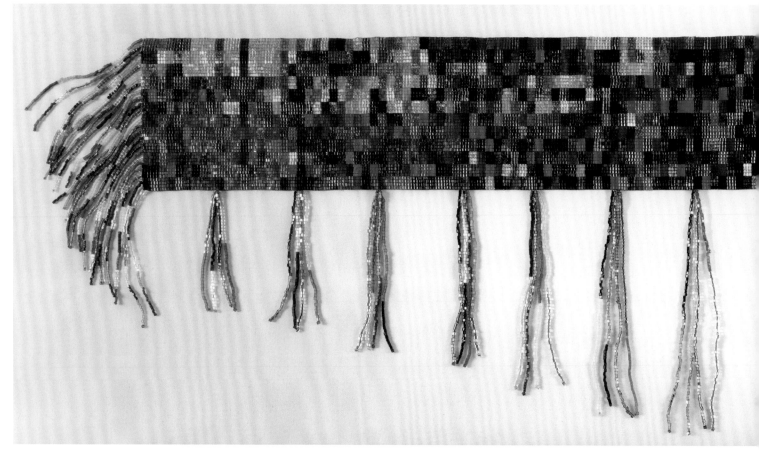

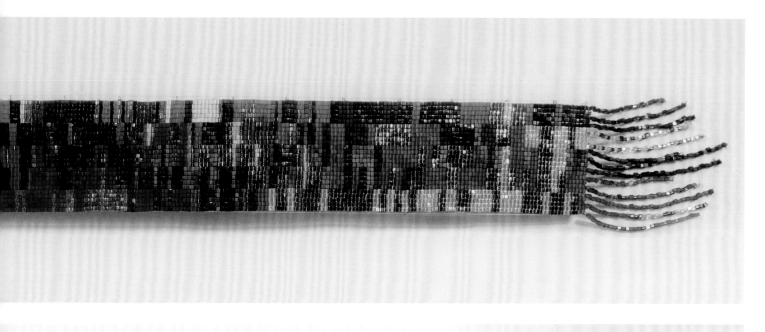

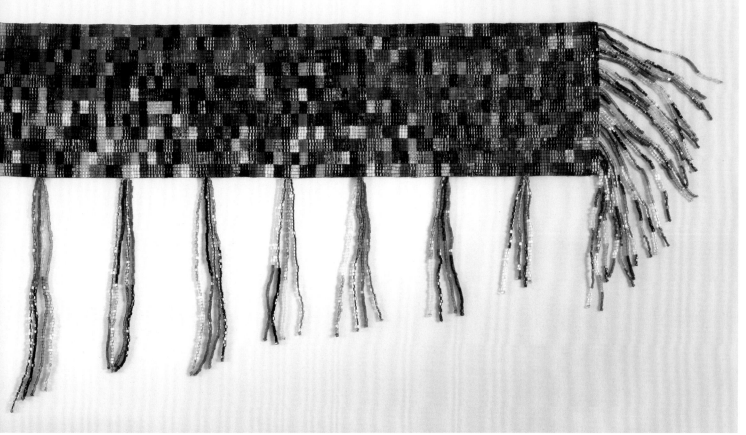

CAT. 3.5 *Nephropathy Burden Strap, DNA Microarray Analysis*, 2009, glass beads and wire, 5 ¼ × 41 × ¼ in., IAIA Museum of Contemporary Native Arts, Santa Fe, NM, Museum Purchase, 2018, ATH-49

CAT. 3.6 *Adrenocortical Cancer Burden Strap, DNA/RNA Microarray Analysis*, 2021, glass beads and wire, 7 ½ × 50 × ¼ in., Courtesy of the artist

CAT. 3.7 *Breast Cancer Burden Strap, DNA Microarray Analysis*, 2018, glass beads and string, 8 × 45 × ¼ in., Museum of Fine Arts, Boston, Edwin E. Jack Fund

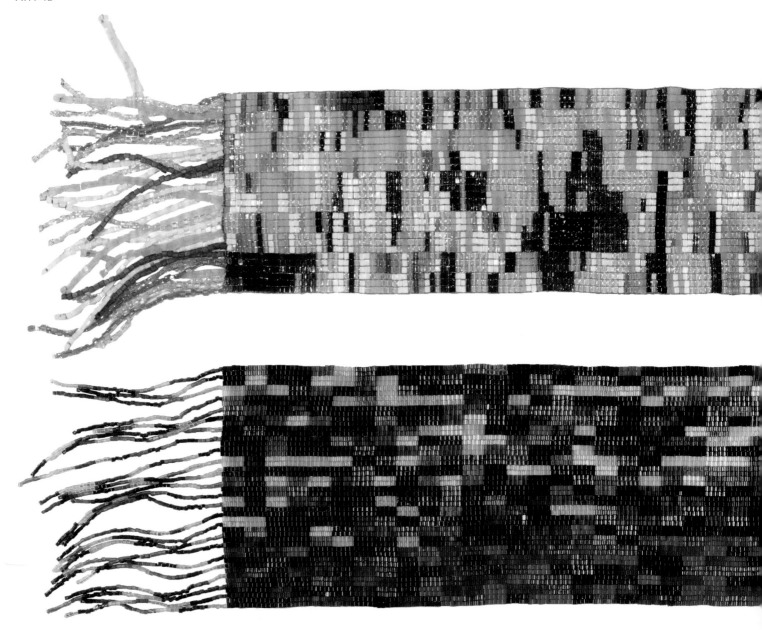

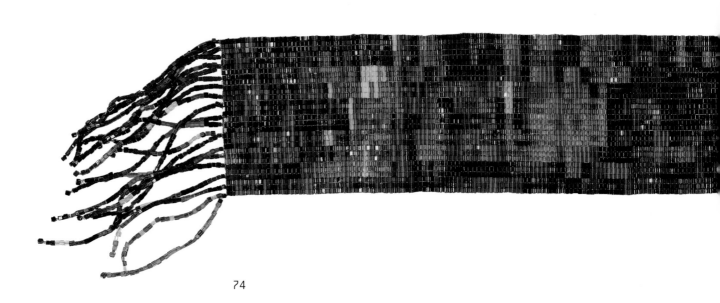

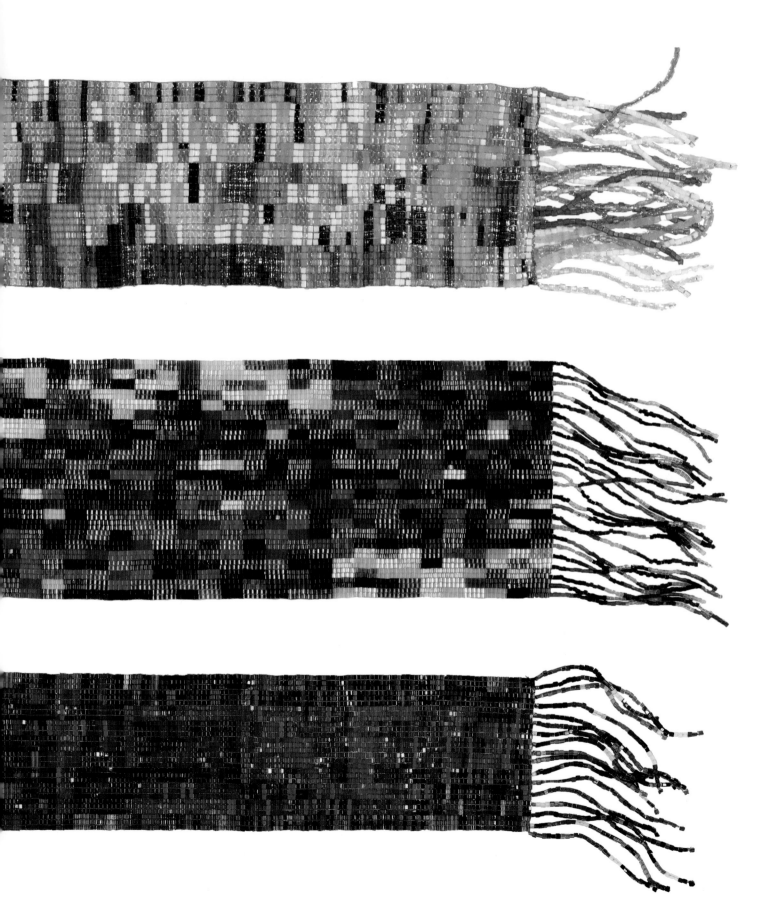

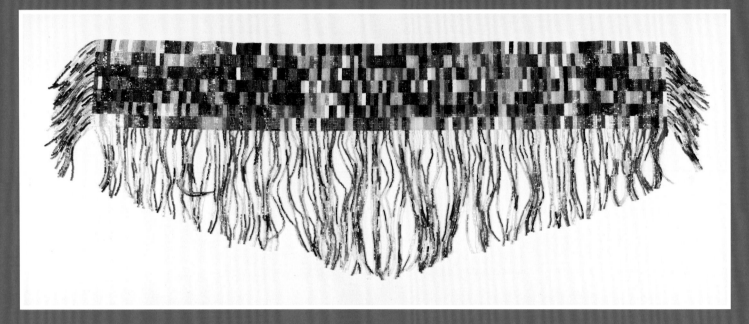

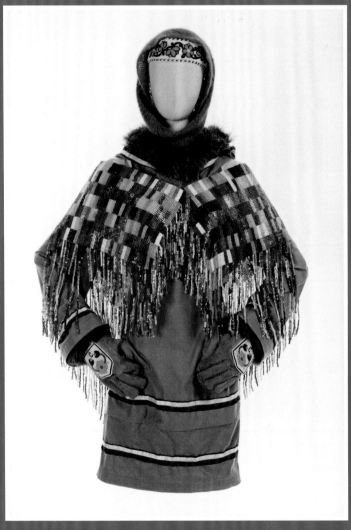

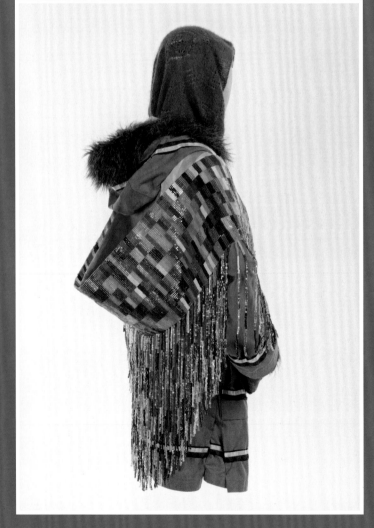

can be expanded proportionately to fit the desired dimensions. The patterns are precisely duplicated from the assay to the loom-woven strap. It is not an aesthetic interpretation, but a precise replication of the test results. Colors assigned in the assays can be the result of a chemical reaction or are assigned digitally. For red-and-green assays, the green fluorescence generally indicates the normal expression of a gene, while the red indicates a mutated or diseased segment. Black and yellow mark inconsequential segments that are either common to or absent from both sequences.[8] The pattern may appear to be pixelated, but it is not. Each colored block represents a match or mismatch in a comparison of genetic samples.

Lord selected microarrays of diseases and conditions that particularly impact Native Alaskans, including her own family members, and other communities exposed to high levels of pollution, poverty, and food insecurity. Lord observed, "Quality health care has a proven relationship with race and socioeconomic status. Because we don't have access to adequate health care, or we don't get tested as often, we don't get diagnosed soon enough. And that leads to us getting sicker or dying at higher rates."[9] *Diabetes Burden Strap, DNA/RNA Microarray Analysis* (**CAT. 3.3**), was the first of her loom-woven beaded burden straps. Diabetes is represented again in a second burden strap with *Nephropathy Burden Strap, DNA Microarray Analysis* (**CAT. 3.5**), demonstrating kidney damage from diabetes. Other diseases represented in the burden strap series are leukemia, adrenocortical cancer, breast cancer, and multiple myeloma (**CATS. 3.4, 3.6–3.8**).

Lord had been thinking about other possible uses for DNA microarray patterns when she came to the idea of adapting them

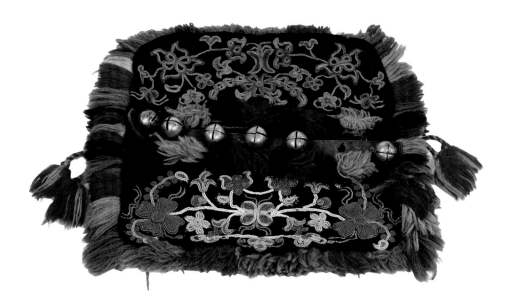

to dog blankets, also called tuppies or tapis.[10] She first learned about the historical use of fancy dog blankets in college by visiting museum collections; tuppies had fallen out of use in her village before she was born. She reported being drawn to these lovingly decorated dog blankets every time she encountered them in collections. Abstracted floral beadwork and embroidery, bright tassels, and large bells make these coats eye-catchingly bright and celebratory (**figs. 3.5** and **3.6**). They are not practical gear for dog sledding. Rather, they are carried along and then the dogs are dressed before a team's arrival for a ceremonial or social event. In the past decade, tuppies have begun to return to use.[11] As Lord says, "Who doesn't want to dress up their dogs?" The efforts to bring COVID-19 vaccines to remote Alaskan Native villages inspired Lord to expand her microarray-patterned tuppies into an entire dog team.

Lord's Alaskan family's village, Nenana, was the departure point for the famous 1925 dog sledding relay that delivered diphtheria antitoxin serum to the site of a deadly outbreak in Nome, Alaska.[12] That journey, which spanned over 674 miles, took twenty mushers and a total of 150 dogs five and a half days to complete. Many of the 1925 mushers were Alaska Natives.[13] Delivering COVID-19 vaccines in 2021 required bush planes,

fig. 3.6 Gwich'in (Kutchin), Sled-dog Blanket, 16 ⅟₆ × 23 ⅝ in., velvet, wool yarn, and glass and metal beads, 1910–25, National Museum of the American Indian, Smithsonian Institution, no. 21/8314

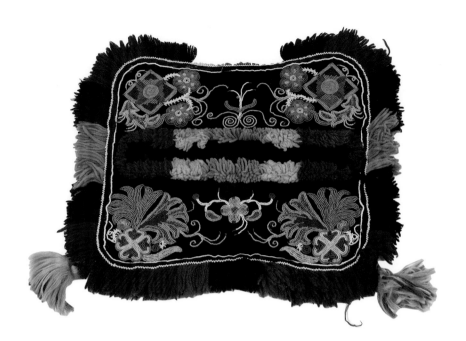

boats, snow mobiles, and even dog sleds. The Yukon-Kuskokwim Health Corporation named its vaccine delivery efforts "Project Togo," in honor of one of the well-known dogs from the 1925 diphtheria run.[14]

Lord's idea grew as the pandemic dragged on, until she assembled enough tuppies to outfit a small sled dog team (**fig. 3.7**). Their blankets carry the disease burdens, but they also deliver the cures: antitoxins and vaccines. The installation of the tuppies, *The Codes We Carry*, is arranged to represent a team of sled dogs. The lead dog's tuppie carries a diphtheria pattern dominated by shades of purple (**fig. 3.8**). The swing dogs, behind the lead dog, wear smallpox and tuberculosis patterns. The smallpox pattern is composed of turquoise, dark blue, smaller amounts of green and yellow, and touches of red. Tuberculosis is mostly navy blue, with some orange, red, and yellow sections, and a bright band of pinks, purples, and turquoise. The fourth dog wears a diabetes pattern of pink, red, and blue. The ovarian cancer tuppie transitions from orange-red to a gradient of pale to dark blues. The tuppies on the dogs closest to the sled display two different microarray patterns representing COVID-19. One has shades of cool greys ranging to black, with patches of bright red. The other is a red and green pattern, with sky-blue bands

fig. 3.7 Schematic for *The Codes We Carry* installation

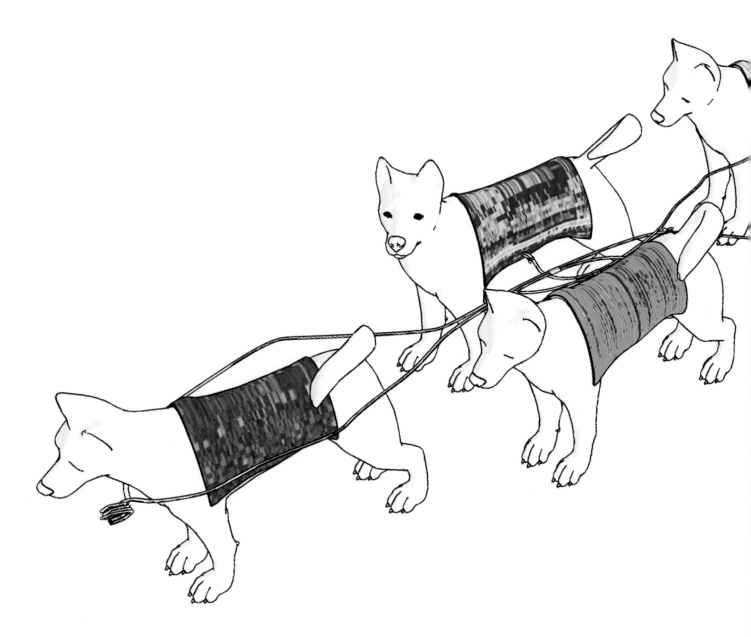

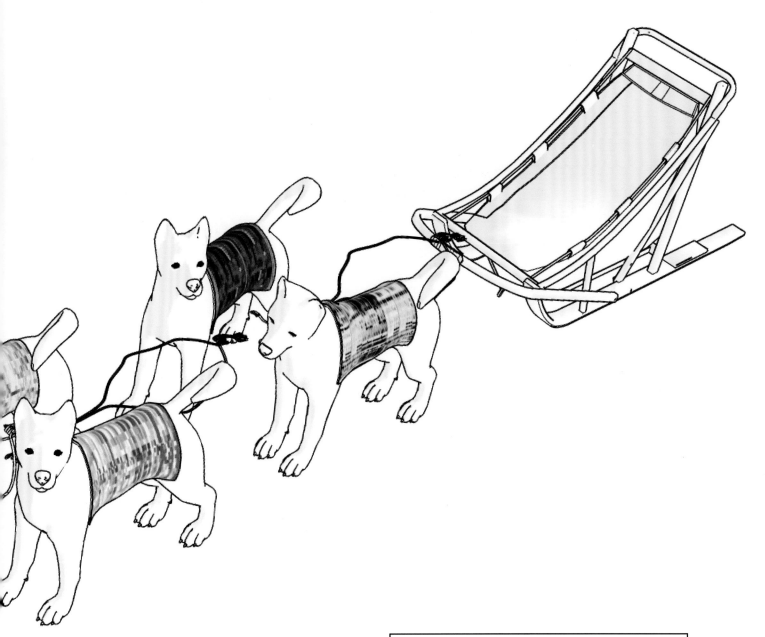

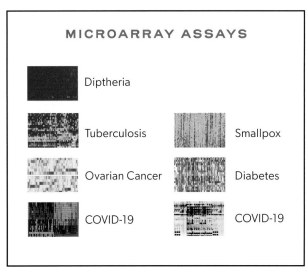

MICROARRAY ASSAYS

Diptheria

Tuberculosis

Smallpox

Ovarian Cancer

Diabetes

COVID-19

COVID-19

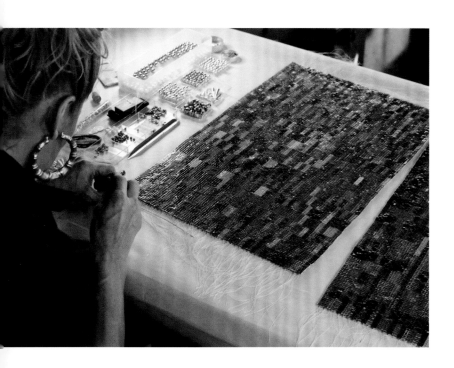

fig. 3.8 Lord working on the diptheria tuppies for *The Codes We Carry*

along some of the edges. Historically, the beaded designs on tuppies are floral (see **figs. 3.5** and **3.6**, pp. 78–79). Lord's use of geometric designs is a departure from that convention, but she trimmed the dog blankets with fabric, fringe, and bells, just as is found in many historic examples.

Through DNA assays, scientists turn diseases into abstract visual representations. Erica Lord borrows these patterns to restore cultural meaning to the abstractions. The highly decorated burden straps used to carry babies are ways of honoring the baby and the family. Dressing sled dogs in finery is a way of honoring the dogs, their cargo, and the people they are arriving to visit. Combining abstract images of diseases with the modes of carrying precious burdens poses thoughtful questions: What burdens do we have to carry with us? What burdens are we honored to carry? And what burdens can we no longer tolerate? Diseases like those explored in Lord's artwork place disproportionate burdens on many Native and other marginalized communities, but individuals have little power to control diseases triggered by endemic environmental pollution. These burdens can only be lifted by changes at the political, environmental, and economic levels. Lord's dog blankets and burden straps bear witness to the impacts of disease while they also bring hope for change, healing, and better times to come.

1 Lara M. Evans, "Setting the Photographs Aside: Native North American Photography since 1990," in *Native Art Now!: Developments in Contemporary Native American Art since 1992*, eds. Veronica Passalacqua, Kate Morris, and James H. Nottage (Indianapolis: Eiteljorg Museum of American Indians and Western Art, 2017), 248–49.

2 Mique'l Icesis Askren, "Erica Lord," in *Manifestations: New Native Art Criticism* (Santa Fe: Museum of Contemporary Native Arts, 2011), 132–33.

3 *The Artifact Piece* is a performance artwork in which James Luna (Luiseño/Puyukitchum/Ipai/Mexican, 1950–2018) exhibited himself lying in a sand-filled display case with accompanying labels describing himself according to anthropological museum practices in use at the time. Some meaningful personal objects belonging to the artist were displayed in additional vitrines. When the artist was not physically present, the impression of his absent form remained in the sand. See Lara Evans, "Artifact Piece, Revisited," in *Action and Agency: Advancing the Dialogue on Native Performance Art*, ed. Nancy J. Blomberg (Denver, CO: Denver Art Museum, 2010), 62–87. The National Gallery of Art, DC, acquired James Luna's *The Artifact Piece* in 2022.

4 Lord made *My First Baby Belt* during graduate school in 2005; she added additional floral beadwork to it in 2007. Lord in discussion with the author, April 2022.

5 Colleen Kim Daniher, "The Pose as Interventionist Gesture: Erica Lord and Decolonizing the Proper Subject of Memory," *E-misférica: Decolonial Gesture* 11, no. 1 (2014), https://hemisphericinstitute.org/en/emisferica-11-1 -decolonial-gesture/11-1-essays/the-pose-as-interventionist-gesture-erica-lord -and-decolonizing-the-proper-subject-of-memory.html.

6 Danyelle Means and Kat Griefen, *Survivance and Sovereignty on Turtle Island: Engaging with Contemporary Art* (Bayside, NY: Kupferberg Holocaust Center and Queensborough Community College, CUNY, 2020), 32, https://www.qcc.cuny.edu/khc/e-catalogs/Survivance-and-Sovereignty-on -Turtle-Island/index.html.

7 Lord obtains the microarray assays from scientific papers in peer reviewed journals. Lord in discussion with the author, April 2022.

8 For a basic and accessible explanation, see the student resource "How DNA Microarrays Work," Nova: Ghost in Your Genes, PBS, accessed August 8, 2022, https://www.pbs.org/wgbh/nova/teachers/activities /3413_genes_02.html.

9 Lord in discussion with the author, March 2022.

10 There are very few published sources about dog blankets, and almost none from Indigenous perspectives, with the exception of the article cited in footnote 11. Métis dog blankets have slightly more historic documentation, but examples in museum collections represent all regions where dog sleds were a customary form of transportation. See Lawrence Barkwell, "Dog Tapis," Saskatoon: Gabriel Dumont Institute of Native Studies and Applied Research Virtual Museum of Métis History and Culture, accessed April 2022, https:// www.metismuseum.ca/media/document.php/14238.Dog%20Tapis.pdf.

11 Michole Eldred, "Tapis: Blankets in Celebration of the Sled Dog," *First American Art Magazine*, no. 24 (2019), 20–25.

12 Gay and Laney Salisbury, *The Cruelest Miles* (New York: W. W. Norton, 2003).

13 Ibid., 263.

14 Yereth Rosen et al., "Native Health Providers Drive Alaska's Vaccination Success Story," *Reuters*, April 12, 2021, https://www.reuters.com/world/usnative -health-providers-drive-alaskas-vaccination-success-story-2021-04-12/.

ERICA LORD (Athabascan/Iñupiat; born Nenana, AK, 1978; resides Santa Fe, NM) is an interdisciplinary artist who explores the contemporary Indigenous experience and the ways in which culture and identity manifest in a rapidly changing world. Lord grew up traveling between the Tanana Athabascan village of Nenana, Alaska, and the Upper Peninsula of Michigan, which inspires her interest in themes of displacement and cultural limbo. Through her work, she examines her mixed-race cultural identity as the daughter of a Finnish-American mother and an Athabascan/ Iñupiat father. Lord uses a variety of media—including photography, beadwork, performance, and large-scale installation work—to construct new, ambiguous, or challenging representations of identity. Her work often acknowledges Indigenous history and uses customary techniques and forms to shed light on pressing current events, like diseases that disproportionately impact Native and other marginalized communities.

Lord received her BA from Carleton College and an MFA at the School of the Art Institute of Chicago. She has taught for many years, most recently as professor at the Institute of American Indian Arts, where she has also been an artist-in-residence. She has exhibited nationally and internationally, including at the Whitney Museum of American Art, the Center for Contemporary Arts and Museum of Contemporary Native Arts (MoCNA), both in Santa Fe, the Musée du Quai Branly in Paris, the National Gallery of Canada, and the Smithsonian Institution's National Museum of the American Indian.

GEO

SOCTOMAH

NEPTUNE

Anya Montiel
Mexican/Tohono O'odham descent

Weaving Identity through a Wabanaki Worldview

THE ASH AND SWEETGRASS BASKETS by Geo Soctomah Neptune dazzle the eyes with iridescent colors and display superb precision—whether in the tiny, rainbow curls on a woven corn cob or in the intricately braided sweetgrass stem on a petite strawberry. Neptune started weaving baskets at the age of four, and by the age of eight they were teaching basketry classes. A member of the Passamaquoddy

Fabanaki Flint Corn (in progress), 2023

Tribe of Maine, part of the Wabanaki Confederacy, they are a master basket maker, educator, and activist living in the Dawnland, the homeland of the Wabanaki in the town of Motahkomikuk (Indian Township).[1] Growing up in a family of artists, Neptune was immersed in Passamaquoddy arts and cultural lifeways. For the Renwick Invitational, they have presented basketry works that honor their family and ancestors while expressing their view of the world and their two-spirit identity.

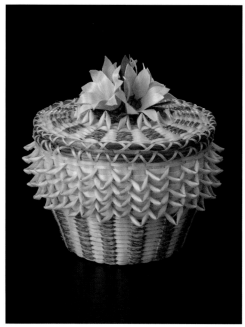

fig. 4.1 Neptune with their grandmother, master basket maker Molly Neptune Parker

fig. 4.2 Molly Neptune Parker (Passamaquoddy), *Basket with Cover*, 2013–14, black and brown ash splints and sweetgrass with commercial dye, overall: 6 11/16 × diam. 20 in., National Museum of the American Indian, Smithsonian Institution, Museum purchase from the artist, 26/9285

Neptune learned basketry from their grandmother, Molly Neptune Parker (1939–2020), a Passamaquoddy master basket maker and family matriarch (**fig. 4.1**). Parker saw basketry as more than a tradition. She remarked, "Basketmaking for me is about innovation and creativity within the context of a traditional art form. The functionality, the materials, and the shapes have been a legacy for each generation. I honor that legacy and believe I have a responsibility to continue it."[2] Parker created her own signature designs and forms (**fig. 4.2**), including woven acorns and strawberries. Neptune remembers that Parker would weave complicated forms that continually challenged her.

In a 2012 interview with the National Endowment for the Arts, Parker referred to Neptune as "a beautiful basket maker" and noted how they created their own designs and personal embellishments on each basket.[3] Parker and Neptune shared more than a grandmother-grandchild relationship; it was also a mentorship. As Parker's student, Neptune wove strawberries that were not completely red but instead a variegation of red, pink, green, and natural ash splints to symbolize their status as a junior weaver—a strawberry that has not yet ripened (**fig. 4.3**). Neptune's miniature strawberry basket from 2013 has two pieces, a top and bottom (**CAT. 4.1**). There are alternating rows of round curls throughout to represent the seeds. The top contains braided sweetgrass for the peduncle, or stem. While

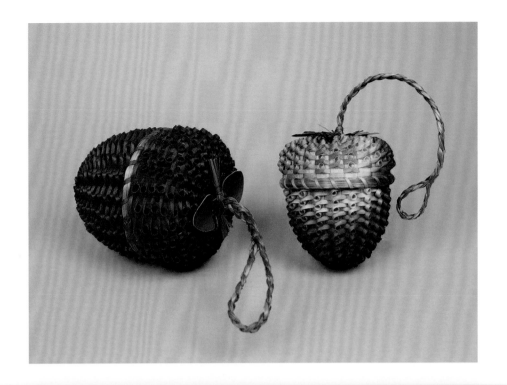

fig. 4.3 *Multigenerational Masters*, 2014, by Molly Neptune Parker (left) and Geo Neptune (right)

CAT. 4.1 *Basket with Cover*, 2013, ash splints and sweetgrass with commercial dye, overall: 7 ⅛ × 8 × 2 ¼ in., National Museum of the American Indian, Smithsonian Institution, Museum purchase from Molly Neptune Parker, 26/9287

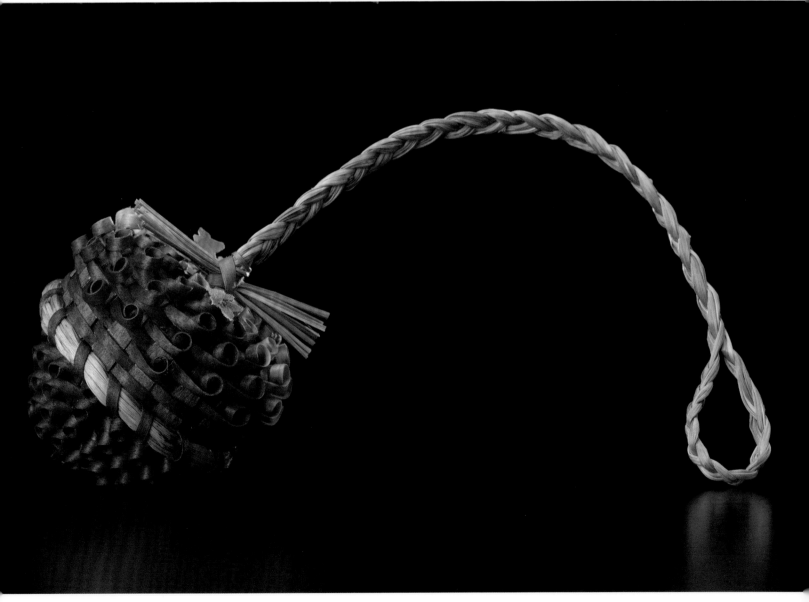

CAT. 4.2 *Heart Medicine (AKA Molly's Berry)*, 2020, black ash and sweetgrass with commercial dye, overall: 6 × diam. 4 ½ in., Courtesy of the artist

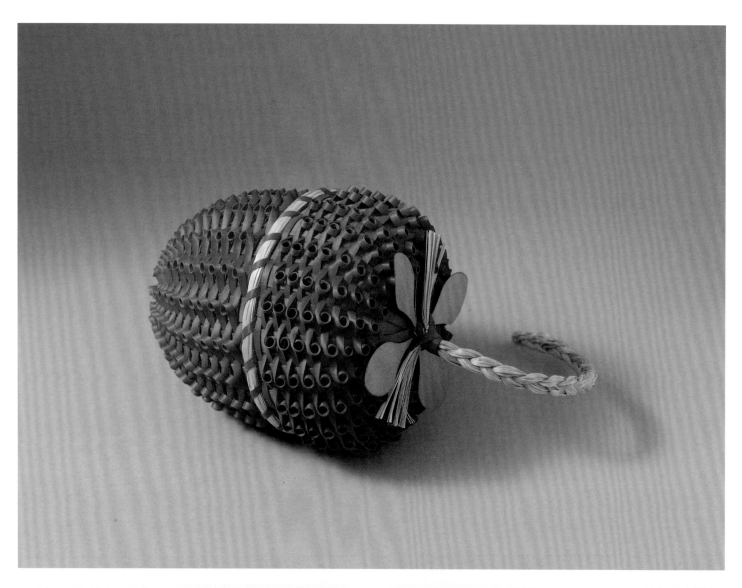

 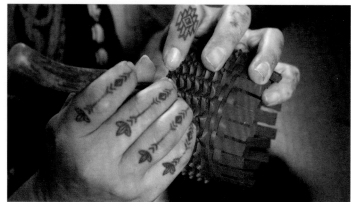

one side is deep red, the other side is unripe and gradates into pink and green.[4]

When Parker passed away in June 2020, the next strawberry basket Neptune wove, entitled *Heart Medicine* (*AKA Molly's Berry*) (**CAT. 4.2**), is a completely red, ripe strawberry. They wove it in a similar shape and design to Parker's. The work is larger than Neptune's basket from 2013, with numerous alternating rows of curled ash splints. The crimson red ash splints catch the eye in contrast to the band of sweetgrass along the rim of the top lid and the braided sweetgrass peduncle. Neptune reflected, "[Parker] being the master and me being her apprentice, I was the growing strawberry until she handed that strawberry to me. I wove this piece with the idea of being able to carry it on and try to heal myself from the pain of her loss."[5] With the passing of Parker, Neptune took on the responsibility of carrying on her legacy and becoming the teacher.

Neptune's artworks are often vehicles of storytelling that can relate Wabanaki teachings to current events. The cylindrical, multicolored basket *Apikcilu Binds the Sun* (**CAT. 4.3**) is one such work drawn from Wabanaki cosmology that carries a modern message. Koluskap is a Wabanaki culture hero sent by the Creator to the Dawnland. He created the Wabanaki, and his teachings continue to guide them. In some stories, Koluskap went on adventures with Apikcilu (Skunk), who originally had a luxurious, all-white coat.[6] Despite his participation in these journeys, Apikcilu felt that the people ignored his contributions and only praised Koluskap. Apikcilu then devised a plan so devious that no one would ignore his actions. He traveled to a faraway mountain that housed Kisuhs, the Sun Bird. When Kisuhs stood atop her mountain and opened her wings, she provided daylight for the

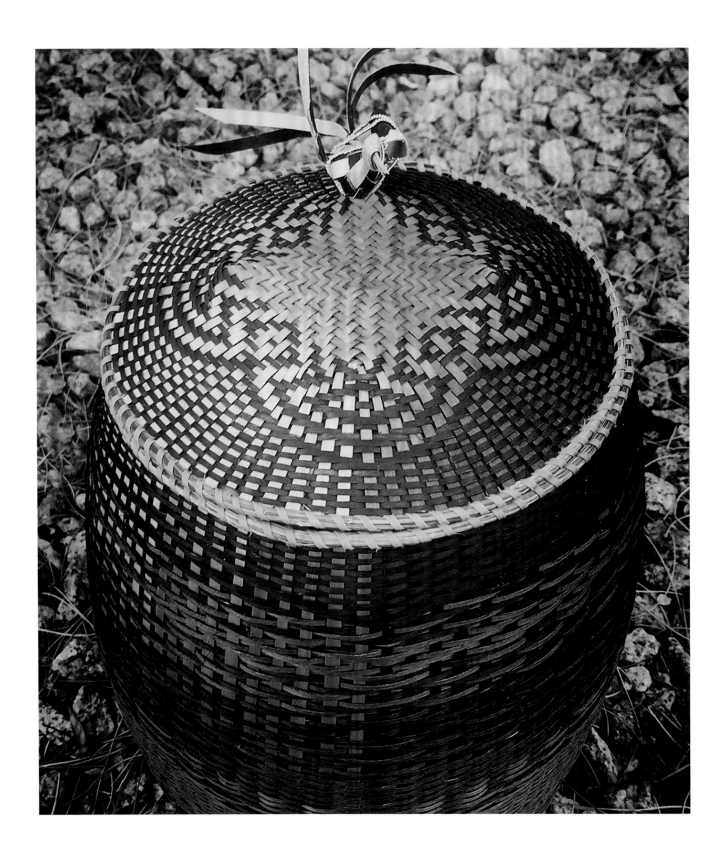

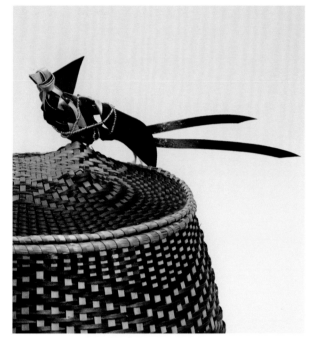

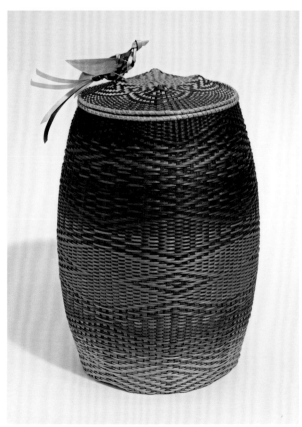

world, and when she closed her wings, nighttime arrived. Apikcilu grabbed Kisuhs, bound her wings, and threw her into a ravine, causing worldwide darkness. Koluskap trekked to the mountain and rescued Kisuhs, but he could only free one wing. Now when Kisuhs stands on her mountain, the extended wing provides sunlight to half of the world while the bound side is in darkness. She slowly makes a full rotation each day, allowing sunlight to reach every part of the globe. As punishment for the spiteful act, Koluskap threw Apikcilu into a fire, scorching his white fur and causing an awful odor. Koluskap then wiped two white stripes down his back to remind Apikcilu of what he lost due to jealousy and malice. From that time forward, skunks have black fur with two white stripes down their backs and emit a repulsive odor.

Neptune's *Apikcilu Binds the Sun* depicts the end of the Wabanaki story, with Kisuhs on top of a pink mountain range woven in relief on the lid. Viewed from above, the top of the lid is divided into two hemispheres, one with ash splints dyed in bright yellow and the other dyed in deep purple. The basket is large and conical with mountain-like diamond and chevron weaves across the sides. Where Kisuhs's open wing extends, that side of the basket is bathed in sunlit yellow and pink colors, suggesting the splendor of sunsets and sunrises. In contrast, the black, dark purple, and blue side of the basket mimics the muted colors of the

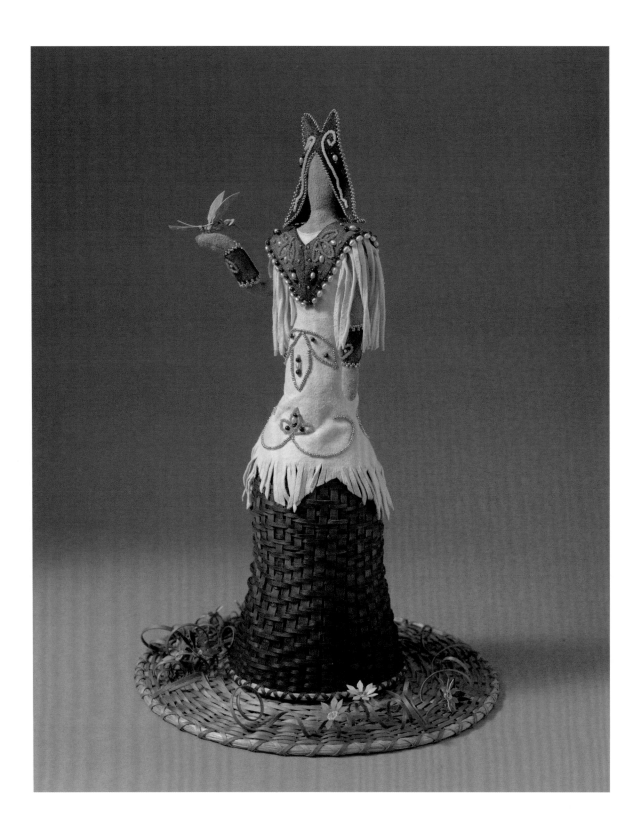

night sky. The bottom of the basket is covered in ocean and powder blues with a wave pattern emanating from the center. Neptune completed the basket in 2018, during the last US presidential administration. They connected the Apikcilu story to abuses of power and the possibility to overcome it: "I believe that Apikcilu had returned....Now he had a coif of white hair and lived in a great, white house. He thought he was better than everyone else and caused much damage, much imbalance in the world. But we have to have faith that Koluskap would find him and rescue the Sun Bird and that Apikcilu would be held accountable one day."[7] In *Apikcilu Binds the Sun*, Neptune illustrates how Wabanaki cosmology imparts contemporary lessons of proper human behavior and consequences for negative behavior.

In 2010, Neptune graduated from Dartmouth College with a bachelor's degree in theater, and that training, they remarked, "encouraged me to focus on the drama of my baskets. For example, I went from my birds just being decorative aspects on the surface to making the birds look as alive as possible. They were no longer part of the basket; they just landed on it."[8] Studying theater lent more narrative qualities and compositions to their baskets. As in a theatrical production, Neptune considers the first to the final acts, along with the background, foreground, colors, and characters in their artworks. While the title *Apikcilu Binds the Sun* remembers the destructive behavior of Apikcilu, the basket instead directs attention to the story's end, with Kisuhs returned to her mountaintop to spread sunlight on part of the Earth.

The mixed-media work *Piluwapiyit: The Powerful One* contains the Wabanaki creation story (**CAT. 4.4**). It is also a self-portrait. The sculpture is a human figure sewn in deerskin, wearing beaded

Wabanaki regalia—a white, fringed dress with a wine-colored collar, cuffs, and double-peaked cap. The figure emerges from the circular woven base of an ash tree on grass dotted with tiny flowers. The Wabanaki are made from the ash tree; Koluskap shot an arrow into the brown ash tree, and the first humans emerged from its bark.[9] Neptune sees themself in this story. When they were born, elders told their mother and grandmother that the child would help the people. Neptune felt different growing up and later came out as two spirit, defined by them as "an indigenous cultural, spiritual, and gender role that holds the sacred space between masculine and feminine energies."[10] They pointed out, "what people struggle with is that they define [two spirit] as a sexual orientation, a gender identity, a spiritual identity, or a societal role. In reality, those four parts are not separate but exist into one intersectional identity."[11] *Piluwapiyit: The Powerful One* depicts Neptune's arrival into their true self.

After living away from home during their high school and college years, Neptune moved back to Motahkomikuk in 2010. They immersed themself in basketry along with education and activism, working across Maine to include Wabanaki content in school curricula and teaching cultural arts to Wabanaki communities. Neptune's spirit name, Niskapisuwin, translates into English as "two-spirit person stands with medicine power," and they have lectured about the historical and cultural significance of two spirits among the Wabanaki.[12] In 2018, they were featured in a video on *them*, an online magazine and community platform from *Condé Nast* featuring the stories and voices of the LGBTQIA+ community. Neptune then became the first openly trans person in Maine elected to a school board in 2020.

Neptune preparing bark
for basket splints

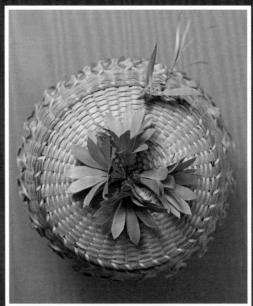

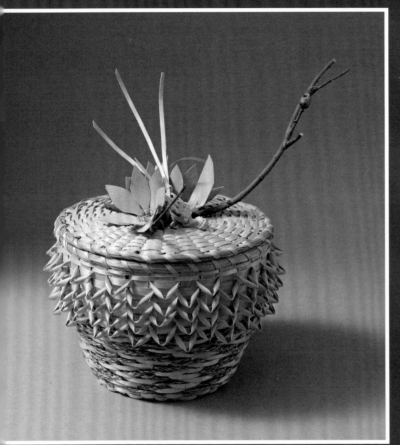

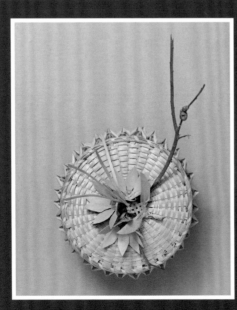

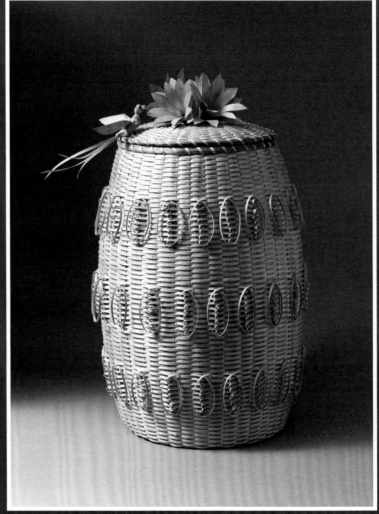

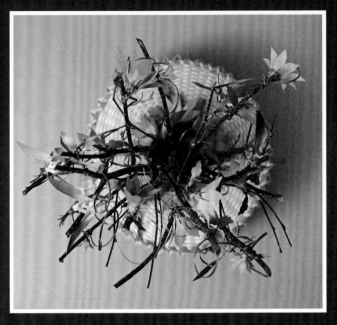

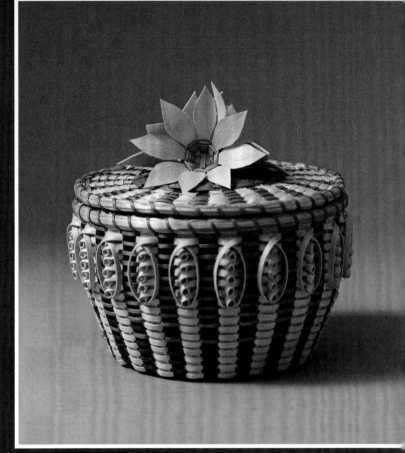

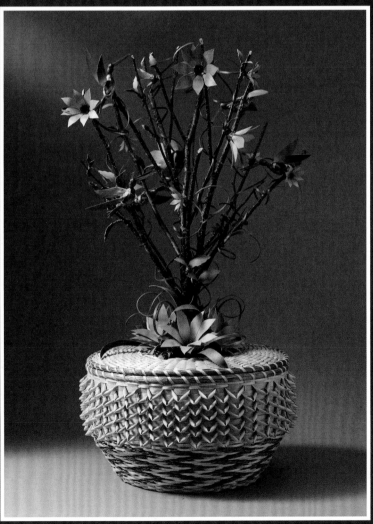

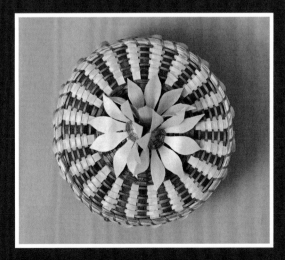

CAT. 4.9 *Strawberry Vine Earrings*, 2022, black ash, sweetgrass, commercial dye, antique French seed beads, antique whiteheart seed beads, 24-karat gold-plated seed beads, freshwater pearl, garnet, and wampum beads, approx. 6 × 1 ½ in. each, Courtesy of the artist

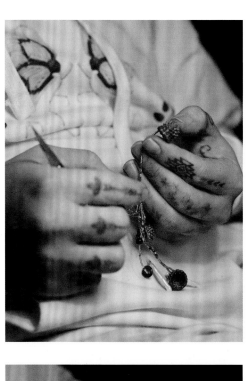

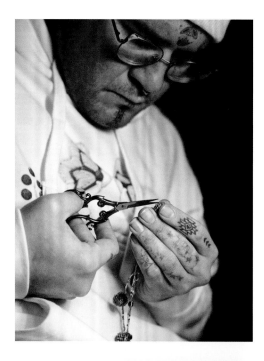

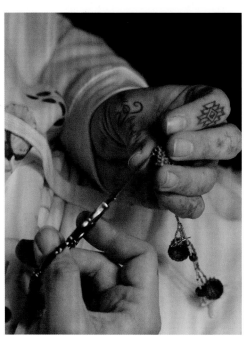

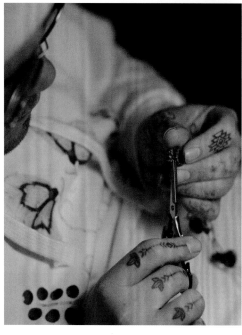

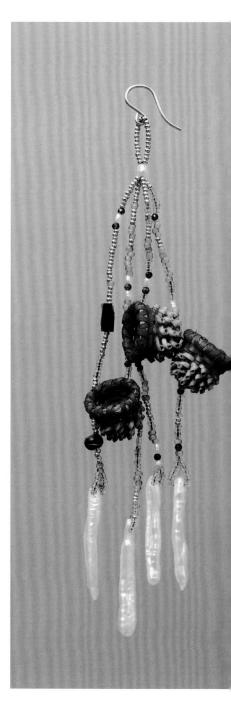

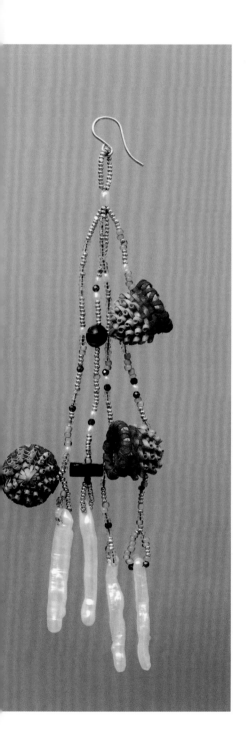

Recently they were named by *Out Magazine* as one of the "18 LGBTQ+ Policy Makers and Advocates Changing the World."[13]

Neptune considers their art to be both an honor and a burden. As they told *First American Art Magazine*, "My ancestors have fought for thousands of generations for me to even have these traditions, so it is my duty to pass them on and preserve them as best as I can for the future generations."[14] Neptune mentioned that fewer Wabanaki are weaving ash baskets, so for those who continue to practice the art, "It can feel like we are the only people carrying that weight."[15]

Along with ash basketry being a time-intensive art that requires selecting a healthy tree, removing the bark, pounding the log, peeling the splints, and cleaning, trimming, and sanding the splints before any weaving can begin, Wabanaki basket makers are caretakers and protectors of the ash tree. The emerald ash borer, an invasive beetle from Asia, has been destroying tens of millions of ash trees in North America through laying eggs in the bark. The resulting larvae feed on the tree, disrupting its ability to absorb nutrients and water. As Neptune explained in 2018, "Nobody in the world is more prepared for the emerald ash borer than the Wabanaki people.... We've been storing seeds. People have been planting seedlings. We've been studying the bug.... We're bracing ourselves [but] our basketmaking traditions will survive."[16] In their creation story, the Wabanaki emerged from an ash tree, and they will always have the honor and burden to care for and protect their sacred tree.

CAT. 4.10 *Chief's Moccasins*
(in progress), 2023, silk ribbons,
antique and contemporary
seed beads, veau velour heeled
boots by Christian Louboutin,
10 × 9 × 7 in. each, Courtesy of
the artist

CAT. 4.11 *Strawberry Lifecycle*
(in progress), 2023, black ash and
sweetgrass with commercial dye,
10 × 5 × 3 in., Courtesy of the artist

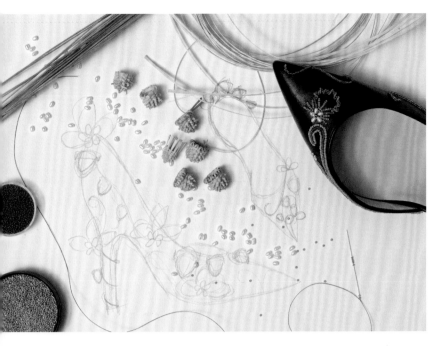

CAT. 4.12 *Redberry Bottoms* (in progress), 2023, black ash and sweetgrass with commercial dye, antique and contemporary seed beads, and leather stiletto heeled shoes by Christian Louboutin, 7 × 9 × 10 in. each, Courtesy of the artist

CAT. 4.13 *Posonutehketossis (The Little Basketmaker)* (in progress), 2023, black ash and sweetgrass with commercial dye, hand-tanned deer skin, hand-dyed deer skin, antique micro beads, freshwater pearls, and semi-precious beads, 18 × diam. 10 in., Private collection

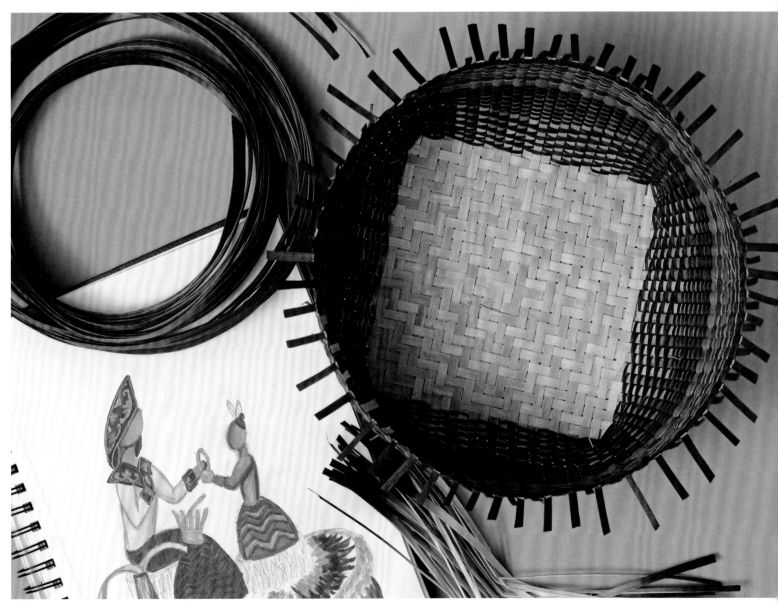

As an Indigenous artist, Neptune has also commented on the burdens of creating art for a mainstream audience. Unlike non-Native artists, Neptune explained that they must bear the burden of "combatting all of these boxes and labels put on us and our art, questioning whether or not it is 'traditional' or even 'Indian' art."[17] Non-Native artists do not have to deal with these exterior perceptions and incessant stereotypes. On the other hand, Neptune cherishes the time they spent with their grandmother and carrying on a family tradition, especially since "basketmaking represents the Passamaquoddy's ability to survive and adapt, and a refusal to conform to that Western lifestyle."[18] The baskets continue to be a Passamaquoddy expression of self.

On the surface, Neptune's baskets are colorful and bright, but they also tell powerful stories and reveal a personal journey. As Parker remarked, basketry is an art that thrives on innovation and creativity. Neptune's artwork builds from cultural knowledge passed along through the generations and speaks to personal experiences and current events. Returning home and recognizing themself as two spirit influenced their basketry and fostered an abundance of creativity. While it might have been easier to be two spirit in a city or metropolitan center, Neptune understands the impact of their presence on the youth in their community. They explained, "Future generations of Wabanaki Two-Spirits are going to experience a world that is much more accepting."[19]

1 The Passamaquoddy, along with the Mi'kmaq, Maliseet, and Penobscot, are part of the Wabanaki Confederacy.

2 "Molly Neptune Parker: Passamaquoddy Basketmaker," National Endowment for the Arts, 2012, https://www.arts.gov /honors/heritage/molly-neptune-parker.

3 Ibid.

4 Many Native Nations, especially those in the Northeast and around the Great Lakes region, wove baskets in the shape of strawberries. Strawberries are considered a medicinal plant, and they are sometimes used in ceremonies or to mark special occasions. Weaving baskets in the shape of berries also demonstrates the skill of the maker to create even curls across the surface and construct the green calyx (sepals) and peduncle (flowering stem) in various ways.

5 Geo Neptune, phone interview with the author, January 31, 2022.

6 Neptune told the Apikcilu story to the author, but the printed version is heavily abbreviated.

7 Neptune, phone interview with the author, January 31, 2022.

8 Jean Mertz-Edwards, "George Neptune," *First American Art Magazine*, no. 9 (Winter 2015/16): 59.

9 Carrie Anne Vanderhoop, "Geo Soctomah Neptune: Reclaiming Tradition," *NBO: National Basketry Organization* 70 (Spring 2018): 24.

10 "Geo Soctomah Neptune," United States Artists, 2021, https://www.unitedstatesartists.org/fellow/geo-soctomah-neptune.

11 Anya Montiel, "LGBTQIA+ Pride and Two-Spirit People: We Are Not Separate from Our Communities: LGBTQIA+ Pride and Two-Spirit People," *Smithsonian Voices*, June 23, 2021, https:// www.smithsonianmag.com/blogs/national-museum-american -indian/2021/06/23/lgbtqia-pride-and-two-spirit-people/.

12 Neptune, "Can We Say Bye-Bye to the Binary?" *Getting Curious with Jonathan Van Ness* (Netflix, 2022), 26 mins., https:// www.netflix.com/title/81206559.

13 Daniel Reynolds, "Geo Soctomah Neptune, Out100 2021: 18 LGBTQ+ Policy Makers and Advocates Changing the World," *Out Magazine*, November 3, 2021, https://www.out. com/print/2021/11/03/out100-2021-18-lgbtq-policy-makers -and-advocates-changing-world#media-gallery-media-8.

14 Mertz-Edwards, "George Neptune," 60.

15 Neptune, phone interview, January 31, 2022.

16 Geo Neptune, "Wabanaki Basketmaking Traditions Under Threat? Art, Culture, and the Future of Maine Indian Basketmaking," October 2, 2018, UNE Maine Women Writers Collection, YouTube video, 1:29:51, https://youtu.be/2_Vg2aZhB_0.

17 Neptune, phone interview.

18 Penelope Green, "Molly Neptune Parker, Basket Maker and Tribal Elder, Dies at 81," *New York Times*, July 15, 2020, https://www.nytimes.com/2020/07/15/us/molly-neptune -parker-dead.html.

19 Reynolds, "Geo Soctomah Neptune, Out100 2021."

GEO SOCTOMAH NEPTUNE (Passamaquoddy; born Indian Township, ME, 1988; resides Princeton, ME) has been weaving baskets since the age of four, when they first began taking lessons from their grandmother, master basket maker Molly Neptune Parker. This mentorship, combined with their prodigious skill, helped Neptune quickly master the artform and develop their own personal style. When just eleven years old, Neptune began teaching with the Maine Indian Basketmakers Alliance. By age twenty, they had earned the title of master basket maker, making them the youngest person to date to receive that honor. Using ash and sweetgrass that they prepare themself, Neptune weaves vibrant narratives that combine Wabanaki teachings with their own perspectives.

In addition to being a skilled basket maker, Neptune is an activist, educator, model, drag performer, and public servant. In September 2020, they were elected to their local school board, becoming the first openly transgender elected official and the first two-spirit person to run for any office in Maine. They used this position to advocate for the increased inclusion of Passamaquoddy language and culture in public curriculums, until resigning in protest in 2022. Neptune has been featured in the Netflix series, *Getting Curious with Jonathan Van Ness*, as well as numerous prominent magazines, including in *them* (2020) and *Vogue* (2022). In 2021 Neptune was awarded the United States Artist fellowship for basketmaking. Their work can be found in collections such as the Bowdoin College Museum of Art and the Smithsonian Institution's National Museum of the American Indian.

MAGGIE
THOMPSON

Lara M. Evans

Cherokee Nation

Sharing Grief and Love

A FIELD OF WHITE-ON-WHITE BEADS shimmers with the repeated text, *I Get Mad Because I Love You* (**CAT. 5.1**). The emotional refrain can be taken multiple ways. Anger and fear are common reactions to situations when a loved one is endangered. These are feelings most people can relate to. But the incessant repetition of the statement becomes sinister. The antiseptic beauty of the materials—seed beads in a selection of white and clear glass—removes any "heat of the moment" connotations, and the phrase becomes a calculated maneuver. The words "I love you" are weaponized. Through deceptively glittering charm, they transform into a way to manipulate another person, citing love as the justification for any type of harmful behavior. This artwork exemplifies Maggie Thompson's artistic practice, which is deeply involved in the work of processing grief and complicated relationships. Some of her works honor sustaining relationships, while others examine the indicators of unhealthy ones.

Thompson's choices of materials, form, and even aesthetics are guided by the emotional content and intent of the work. She employs a wide range of handwork and machine textile techniques, a result of having learned quilting, knitting, crocheting, and sewing as a child growing up in Minneapolis. She studied

On Loving, 2022, (detail, see p. 113)

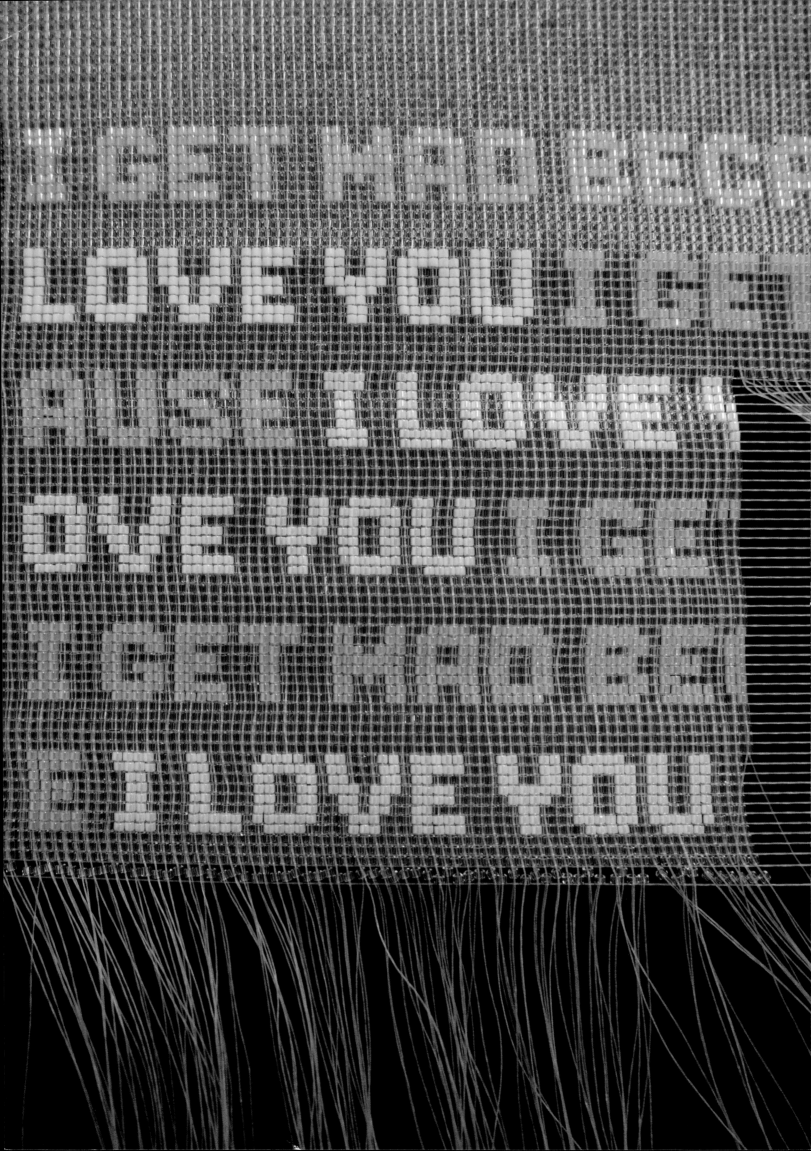

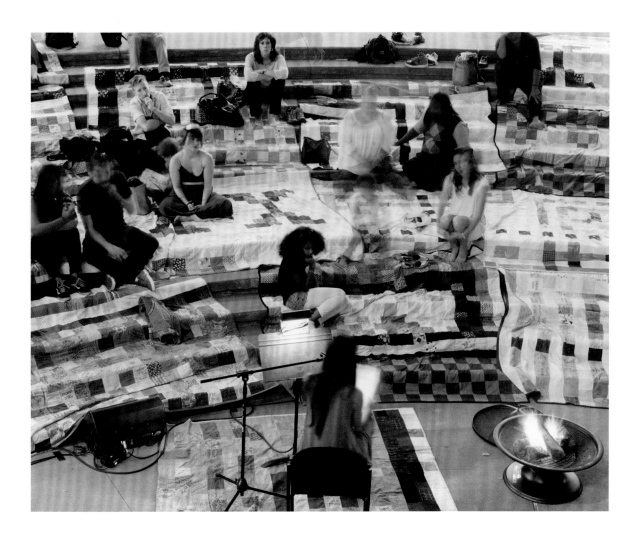

CAT. 5.1 *I Get Mad Because I Love You* (in progress), 2021–22, glass beads and filament, 48 × 72 × 1 in., Courtesy of the artist

fig. 5.1 Participants of *Then a Cunning Voice and a Night We Spend Gazing at Stars*, 2017

architecture for a year at Rhode Island School of Design, but she was drawn back to the handcrafting she grew up with after taking a machine knitting course and received her degree in textiles.[1] Thompson sees her mother's many years of hospice work, combined with growing up in an artistic family, as having normalized her practice of introspection and personal growth through making meaningful objects.

Her current practice includes artists she is particularly close to and counts on for ongoing artistic support. These include painters Jim Denomie (Ojibwe) and Jennifer Rappaport, multimedia artist Dyani White Hawk (Sičáŋǧu Lakota), and Thompson's own mother, artist Peggy Thompson. Relationships with other artists are an important part of her practice, as evinced by her engagement in several collaborative projects. She organized the creation of a four-thousand-square-foot modular quilt produced from numerous sewing bees for Emily Johnson's overnight public performance *Then a Cunning Voice and a Night We Spend*

CAT. 5.2 *The Equivocator*, 2021,
rope, wire, stockings, thread, and
ribbon, 42 × 66 × 6 in., Collection
of Hair and Nails

Gazing at Stars (**fig. 5.1**) in New York in 2017.[2] She also collaborated with artists Jaida Grey Eagle (Oglala Lakota), Tyler Hawkinson, Sarah Nassif, Kerri Sandve, and more for *The Protest Mask Project* in 2020 in response to George Floyd's murder.[3] Projects such as these are a feature of Indigenous art practices that has gained new interest under the label of "socially engaged art."[4] In addition to creating installation artwork and socially engaged collaborative work, Thompson is also a textile artist. This kind of multitrack approach is not unusual for Native American artists. Many find themselves working in seemingly separate modes that engage with quite different audiences and economic niches. Thompson, for example, founded her own machine knitwear business, Makwa Studio, in 2014 (**fig. 5.2**). Her machine-knitted cowls, scarves, and beanie designs are inspired in part by patterns and colors seen in Ojibwe beadwork and quillwork, but she sources images from many different parts of her life. Figuring out ways of honoring traditional patterns and symbolism while adapting them to new purposes is a heavy responsibility that Native artists like Thompson must continuously navigate. Whether her knitwear features a backbone pattern, star symbolism, or Ojibwe text, it is an outlet for beauty, healing, and occasionally humor. Her socially engaged collaborative works focus on building community and addressing large-scale social issues. Thompson's installation work, represented in this year's Renwick Invitational, is perhaps her most introspective and contemplative.

Whereas *I Get Mad Because I Love You* uses coldly beautiful aesthetics to beguile the viewer, *The Equivocator* (**CAT. 5.2**) viscerally evokes a gut feeling of wrongness. Loops of hosiery "intestines" are stuffed with rope and suspended in air, their weight dragging them lower and lower, straining against their

fig. 5.2 Thompson in her studio in Minneapolis in front of knitting machine

wire connections.[5] Red ribbons stand out in contrast to the sheer expanse of swollen, flesh-toned stockings. The red flags in *The Equivocator* stand for the moments when our internal alarm bells go off, warning us that a situation is not right. Thompson describes this work as "A belly tied in knots with the red flags that you so delicately placed but insisted did not exist."[6] This statement always accompanies the work. The artist uses the word "you" to directly confront the abuser and their gaslighting behavior.[7] With this statement, *The Equivocator* becomes evidence of ill intent and bears witness to the knowledge of the body. The gut feeling is not a cliché.

Thompson's work brings forth how emotional abuse is more difficult for many to recognize than physical abuse, whether that is in a romantic relationship, a friendship, a parental relationship, or a work situation. Learning to recognize unhealthy relationship patterns is grueling, but it is key to changing behaviors and seeking safety and healing. For Thompson, *The Equivocator* and *I Get Mad*

Thompson working on *I Get Mad Because I Love You* (see p. 106)

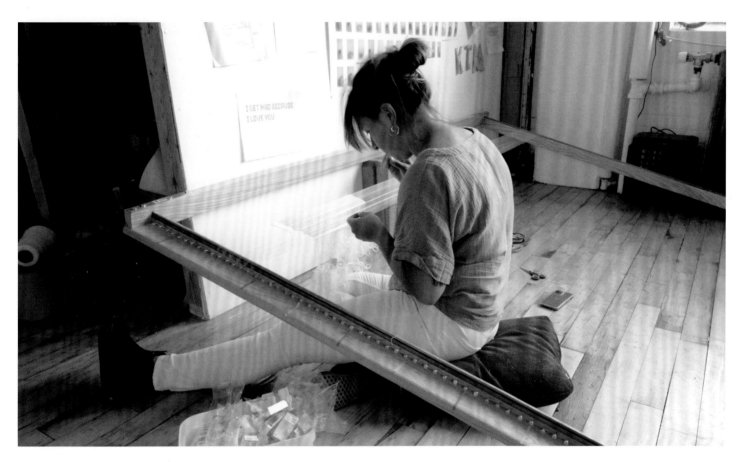

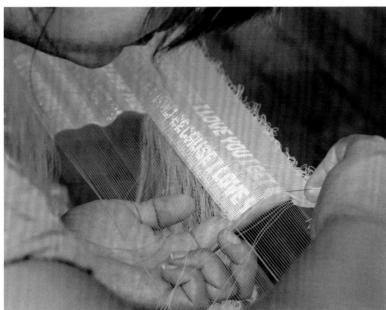

CAT. 5.3 *On Loving* (in progress), 2022–23, vinyl, glass beads, thread, and zippers, four bags: 90 × 42 × 10 in. each, Courtesy of the artist

Because I Love You turn complex interpersonal concepts into concrete physical objects. The artist describes these works as meditations on small moments that feel "off." Her art is a way to recognize, process, and heal.

Returning to *I Get Mad Because I Love You*, Thompson says, "It's all about the words.... Even though someone's mistreating you and you know that's happening, you still hold onto them saying, 'I love you.' You disregard the anger and the lashing out. All that kind of stuff, you put on the backburner and all you see is 'I love you'.... You get stuck, repeating the same memory or phrase or thought over and over and over again."[8] Thompson described the labor-intensive process of loom weaving the size eleven beads[9] (**fig. 5.3**) as helpful for processing her experience with unhealthy relationships and seeing how far she has come. Of these works, she says, "I don't think I could have made these any earlier. I feel like [it's] because I am in a more stable position in my life that I'm able to finally create them."[10]

While *I Get Mad Because I Love You* and *The Equivocator* present us with the emotional burdens of unhealthy relationships, they also function as part of the healing process, not just for the artist, but for us as viewers. Naming the problem is a first step to creating change. The discomfort created by the repeating beaded text in *I Get Mad Because I Love You* and the accusatory "you" in the artist's statement accompanying *The Equivocator* point to a path forward in healing from emotional abuse through reasserting and honoring one's personal integrity.

Thompson's installation, *On Loving* (**CAT. 5.3**), processes another emotional and universal human experience: grief. It is not Thompson's first work exploring this subject. She describes an earlier, related work, *For Love Alone* (**fig. 5.4**), from 2016:

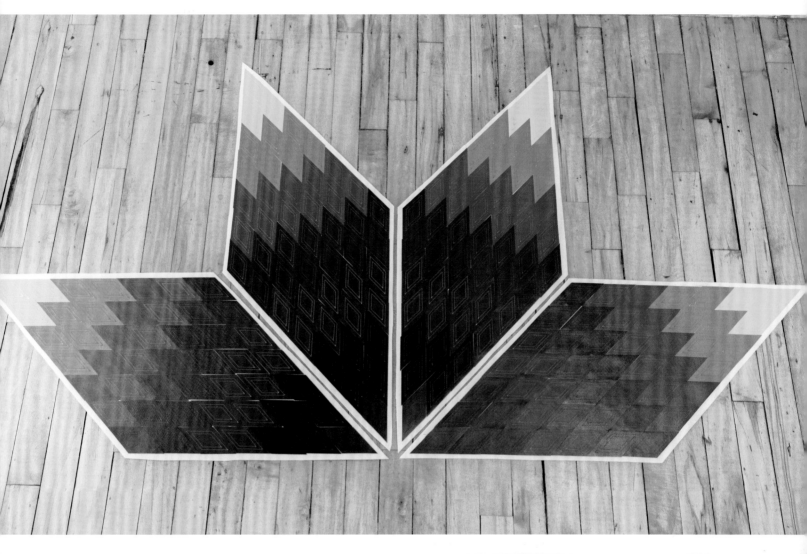

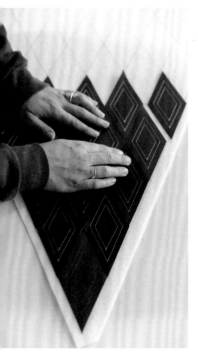

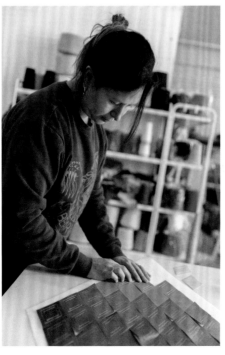

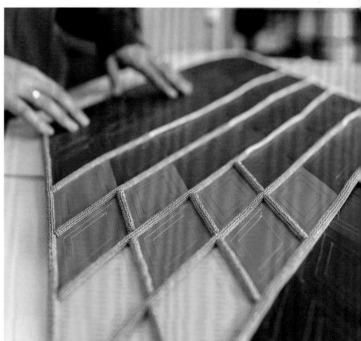

This piece is a star quilt made out of vinyl that is sewn into the shape of a body bag. It was inspired by my experience of watching the coroners come in carrying a simple, solid colored bag the night my dad passed away. After this I was compelled to create my own body bag as an act of saying goodbye and as a way to honor my dad. Although the body is only carried in this bag for a small moment in time, I couldn't bear the thought of him being in something so plain and simple. The colors of the star are based on a star quilt my mom made my dad when they were first married.... The beads add a decorative quality to the piece and the arms of the star wrap around the bag as a way of wrapping and holding a body in that love.[11]

fig. 5.4 *For Love Alone*, 2016, vinyl, glass beads, thread, and zippers, 90 × 42 × 10 in., Courtesy of the artist. Installation view, 2021, *Dakobijige "She Ties Things Together"—Maggie Thompson*, Watermark Art Center, Bemidji, MN

The work included in the Renwick Invitational, *On Loving*, presents us with the quilted vinyl body bag in multiples as an installation artwork. Quilting may not immediately come to mind as a Native American customary practice. It was adopted from Euro-Americans and then acquired a number of specialized cultural uses, with particular patterns symbolic of complex group relationships and cosmologies. Quilts are created and gifted to recognize transitions in life. They are displayed for certain ceremonies and social gatherings, with details varying from one tribal community to another.[12] Whether displayed on a wall, on the ground, on a casket, or bestowed as a gift, quilts are signifiers of an honoring taking place. Blankets, as a general category of object, are useful for conferring honors in mixed tribal gatherings. Displaying a star quilt is a public affirmation of honoring. By incorporating a pieced star pattern stitched into a body bag, Thompson publicly confers honor and respect for the body of the loved one.

Thompson created the series of body bags for the installation *On Loving* to honor the grief of the living as well as those lost during these difficult years since COVID-19 began sweeping across the world. The conditions of the pandemic, especially early on, interrupted customary funerary practices that help us grieve. The mortality rate for Native Americans was far out of balance with our population numbers, creating an outsized burden of grief. CDC data shows the COVID-19 mortality rate in 2021 was higher among Native Americans than for any other population group and almost two-and-a-half times higher than that of white and Asian Americans. The mortality rate was higher among the Native population for all age groups, too, not just for the elderly.[13] Life expectancy dropped by six years.[14] But all

115

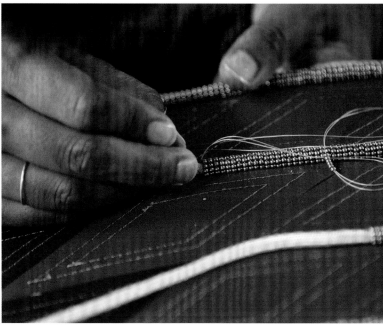

fig. 5.5 Thompson sewing beads onto body bag for *On Loving*

communities, everywhere, have experienced incredible loss. The COVID-19 pandemic has caused grief on a scale that this generation of Americans has not previously experienced. Thompson's body bags honor that grief. The artist chose a new color palette for the contemplative installation for the Renwick Gallery, replacing the black vinyl of *For Love Alone* with white vinyl in *On Loving*. She also embellished the pieced morning star pattern with beadwork to add texture and shimmering light (**fig. 5.5**). Through her meticulous handcraft, Thompson transforms a painfully anonymous, utilitarian object—the body bag—into a beautiful honoring of those we have lost.

Thompson's art grapples with the burdens of grief and trauma by interweaving them with honor, beauty, and healing. Relationships are at the core of her practice. Whether through collaboration with other artists or by using her work to process deep complexities, she honors connections to loved ones and unburdens herself of unhealthy relationships. Through her installation work, Thompson delves into personal experiences, exteriorizing them into objects so that they might be seen, touched, and understood. She makes visible feelings and burdens that are often hidden, asking us to honor our deepest selves.

1 Jaida Grey Eagle, "How Makwa Studio Knits Together Art, Activism, and Business," *Minnesota Monthly*, March 8, 2021, https://www.minnesotamonthly.com/lifestyle/style-shopping /how-maggie-thompson-at-makwa-studio-knits-together-art -activism-and-business.

2 Megan Guerber, "Maggie Thompson's Quilt Collaboration," *American Craft Council*, December 8, 2017, https://www.craftcouncil.org/post/maggie-thompsons-quilt -collaboration. To learn more about Johnson's project, see the project page on the artist's website: http://www.catalystdance. com/then-a-cunning-voice.

3 "The Protest Mask Project," Actipedia, https://actipedia .org/project/protest-mask-project, accessed April 2022. See also Maggie Thompson, "The Protest Mask Project," Makwa Studio, http://makwastudio.com/the-protest-mask-project, accessed April 2022.

4 Examples of projects that can be understood as socially engaged art include *Walking with Our Sisters* (2012–19), a commemorative art installation that honored the lives of missing and murdered Indigenous women, and multiple projects lead by artists Cannupa Hanska Luger (Mandan/Hidatsa/Arikara/Lakota) and Marie Watt (Seneca).

5 Thompson initially thought to make *The Equivocator* using knitting techniques but was inspired by Maria Ezcurra's work to use nylon hosiery instead. The meanings of the material are dense, as hosiery suggests intimacy, voyeurism, fleshliness, and fakery, and is simultaneously strong and delicate. Rachel Felder, "Pantyhose that Make You Think," *New York Times*, September 27, 2019, https://www.nytimes.com/2019/09/27 /arts/design/pantyhose-gossamer-margate.html.

6 Thompson, artist's website, accessed April 2022, http://makwastudio.com/gallery/the-equivocator.

7 According to the National Domestic Violence Hotline, gaslighting "is an extremely effective form of emotional abuse that causes a victim to question their own feelings, instincts, and sanity, which gives the abusive partner a lot of power." "What Is Gaslighting?," National Domestic Violence Hotline, accessed August 11, 2022, https://www.thehotline.org/resources/what -is-gaslighting.

8 Thompson in discussion with the author, February 2022.

9 Bead sizing generally refers to the average number of beads that will fit within one inch when lined up hole-to-hole. For example, a size eleven bead is larger than a size fifteen bead.

10 Thompson in discussion with the author, February 2022.

11 Ibid.

12 Marsha L. MacDowell and C. Kurt Dewhurst, *To Honor and Comfort: Native Quilting Traditions* (Santa Fe: Museum of New Mexico Press, 1997), 4–5.

13 Randall Akee and Sarah Reber, "American Indians and Alaska Natives Are Dying of COVID-19 at Shocking Rates," *Brookings*, February 18, 2021, https://www.brookings.edu /research/american-indians-and-alaska-natives-are-dying-of -covid-19-at-shocking-rates.

14 Simon Romero, Roni Caryn Rabin, and Mark Walker, "How the Pandemic Shortened Life Expectancy in Indigenous Communities," *New York Times*, August 31, 2022, https://www .nytimes.com/2022/08/31/health/life-expectancy-covid-native -americans-alaskans.html.

CATHERINE "MAGGIE" THOMPSON (Fond du Lac Ojibwe; born Minneapolis, MN, 1989; resides St. Paul, MN, with a studio in Minneapolis, MN) is a textile artist and designer who derives inspiration from her Ojibwe heritage, family history, and the contemporary Native American experience. Thompson pushes the viewer's understanding of textile art by combining photographs, found objects, stockings, beadwork, and more. Through large-scale work and installations, she brings form to emotional experiences and creates a visual way to process complex topics.

Thompson received her BFA in textiles at the Rhode Island School of Design (RISD) in 2013. She had her first solo exhibition, *Where I Fit*, at All My Relations Gallery in Minneapolis in 2014. Since then, Thompson has exhibited at regional institutions such as the Minneapolis Institute of Art and the Plains Art Museum in Fargo, North Dakota. In 2015, she received support from the Minnesota State Arts Board Cultural Community Partnership grant and the Native Arts and Cultures Foundation Regional Fellowship to create a body of work for her exhibit at the Minnesota Textile Center, *On Borrowed Time*, which explores themes of grief around her experience of losing her father.

In addition to her fine arts practice, Thompson runs Makwa Studio, a small knitwear business based in Minneapolis. She is also an emerging curator of contemporary Native art and has worked on exhibitions at the Two Rivers Gallery, the McKnight Foundation, and the Minnesota Museum of American Art.

SHARING HONORS AND BURDENS

Renwick Invitational 2023

Works in the Exhibition

Objects are arranged by artist, then chronologically, then alphabetically by title.

Dimensions are given as height by width by depth

Joe Feddersen

Tire, 2003
blown and sandblasted glass
14 ½ × diam. 12 ¾ in.
National Museum of the American Indian,
Smithsonian Institution, Museum purchase
from the artist, 26/2874
CAT. 1.1 (p. 26)

Horses and Deer, 2020
blown and sandblasted glass
13 ½ × 11 ¾ × 10 in.
Smithsonian American Art Museum, Museum purchase
through the Kenneth R. Trapp Acquisition Fund, 2021.34
CAT. 1.2 (p. 26)

Bestiary 4, 2021
monoprint
44 × 30 in.
Courtesy of the artist
CAT. 1.11 (p. 35)

Bestiary 5, 2021
monoprint
44 × 30 in.
Courtesy of the artist
CAT. 1.10 (p. 33)

Bestiary 11, 2021
monoprint
44 × 30 in.
Courtesy of the artist
CAT. 1.12 (p. 35)

Canoe Journey, 2021
twined waxed linen
7 × diam. 5 in.
Colville Tribal Museum, Confederated
Tribes of the Colville Reservation
CAT. 1.4 (p. 29)

Omak Stampede, 2021
twined waxed linen
9 × diam. 6 in.
Courtesy of the artist
CAT. 1.5 (p. 29)

Roll Call, 2021
twined waxed linen
7 ¾ × diam. 6 ¾ in.
Private collection, Boston
CAT. 1.3 (p. 29)

Social Distancing series, 2021
mirrored and blown glass
six vessels: approx. 16 × diam 8 in. each
Anonymous; Museum of Glass, Tacoma, WA,
Gift of the artist; and Courtesy of the artist
CATS. 1.6–1.9 (pp. 30–31)

Fish Trap, 2021–22
fused glass and metal
24 × 72 × 24 in.
Courtesy of the artist
CAT. 1.15 (pp. 38–39)

Canoe Journey, 2022
monoprint
triptych: 44 × 30 in. each
Courtesy of the artist
CAT. 1.13 (p. 35)

Charmed (Bestiary), 2022–23
fused glass and filament
approx. 120 × 180 × 10 in.
Courtesy of the artist
CAT. 1.14 (pp. 36–37)

Lily Hope

Lineage Robe, 2017
thigh-spun merino and cedar bark
with beaver fur
48 × 52 ½ × 2 in.
Portland Art Museum, OR, Museum Purchase: Funds
provided by bequest of Elizabeth Cole Butler by exchange
CAT. 2.5 (p. 51)

In collaboration with Ricky Tagaban (Tlingit)
Double Raven Chilkat Dancing Blanket,
2020
thigh-spun merino and cedar bark with fur
51 × 54 × 2 in.
Collection of Betsy Nathane
CAT. 2.6 (p. 51)

Woven Chilkat Protector Masks, 2020
thigh-spun merino and cedar bark
with tin cones and ermine tails
three masks: 8 × 7 × 2 in. each
Anonymous and The Hope Family Trust
CAT. 2.1 (p. 48)

Clarissa's Fire Dish, 2021
cedar bark and merino
13 × 7 × 1 ½ in.
The Hope Family Trust
CAT. 2.2 (p. 50)

Memorial Beats, 2021
thigh-spun merino and cedar bark with
copper, headphones, and audio files
16 × 4 × 10 in.
The Hope Family Trust
CAT. 2.3 (p. 50)

Tlingit CEO, 2022
thigh-spun merino and cedar bark
with copper cones, jacket: 44 in. long,
boots: men's size 10 ½
headdress and cane created by
Eechdaa Dave Ketah (Tlingit)
The Hope Family Trust
CAT. 2.4 (p. 50)

Between Worlds (child's robe), 2022–23
thigh-spun merino and cedar bark
with beaver fur
33 × 36 × ¼ in.
The Hope Family Trust
(See adult robe, pp. 44–45)

Ursala Hudson

Lightening at Dawn, 2021
bodice: merino, silk, leather, and plastic
boning; bag: merino and leather; hat:
vintage wool hat, merino, silk, feather,
and mother of pearl, women's size 6
Courtesy of the artist
CAT. 2.10 (p. 57)

Matriarch Rising, 2021
collar: merino, silk, steel cones, and
leather; *Electrified Heart* apron: merino,
silk, leather, and steel cones; hat:
vintage wool hat, merino, silk, and
mother of pearl, women's size 6
Courtesy of the artist
CAT. 2.8 (p. 54)

Tideland Warrior, 2021
headpiece: merino, feathers, and mother
of pearl; shawl: merino, silk, mountain goat
fur, and mother of pearl; wrap: merino,
silk, leather, and Tencel, women's size 6
Courtesy of the artist
CAT. 2.9 (p. 56)

We Are the Ocean, 2021
collar: merino, silk, steel cones, and leather;
Woman as Wave robe: thigh-spun merino
and cedar bark with silk; *Tidal* apron: merino,
silk, leather, steel cones, and Tencel,
women's size 6
National Museum of the American Indian,
Smithsonian Institution, Purchased with support
from the Ford Foundation, 27/717
CAT. 2.7 (p. 53)

Sister Bear, 2022–23
thigh-spun merino and cedar bark with silk
36 × 32 × ¼ in.
Courtesy of the artist
(See template, p. 55)

Erica Lord

Blood Quantum (1/4 + 1/16 = 5/16),
from the series *Tattooed Arms*, 2007
inkjet print, 14 × 40 in.
Courtesy of the artist
CAT. 3.1 (p. 71)

*Enrollment Number
(11–337–07463–04–01)*,
from the series *Tattooed Arms*, 2007
inkjet print, 14 × 40 in.
Courtesy of the artist
CAT. 3.2 (p. 71)

*Diabetes Burden Strap, DNA/RNA
Microarray Analysis*, 2008
glass beads and wire
4 × 55 ½ × 1 ¼ in.
Municipality of Anchorage, AK | Public Art Program
CAT. 3.3 (pp. 72–73)

*Nephropathy Burden Strap,
DNA Microarray Analysis*, 2009
glass beads and wire
5 ½ × 41 × ¼ in.
IAIA Museum of Contemporary Native Arts,
Santa Fe, NM, Museum Purchase, 2018, ATH-49
CAT. 3.5 (pp. 74–75)

*Breast Cancer Burden Strap,
DNA Microarray Analysis*, 2018
glass beads and string
8 × 45 × 2 in.
Museum of Fine Arts, Boston, Edwin E. Jack Fund
CAT. 3.6 (pp. 74–75)

*Adrenocortical Cancer Burden Strap,
DNA/RNA Microarray Analysis*, 2021
glass beads and wire
7 ½ × 50 × ¼ in.
Courtesy of the artist
CAT. 3.7 (pp. 74–75)

*Leukemia Burden Strap,
DNA/RNA Microarray Analysis*, 2022
glass beads and wire
7 ½ × 94 ½ × ¼ in.
Courtesy of the artist
CAT. 3.4 (pp. 72–73)

Multiple Myeloma Burden Strap,
DNA/RNA Microarray Analysis, 2022
glass beads and wire
7 × 60 × ¼ in.
Courtesy of the artist

CAT. 3.8 (p. 76)

The Codes We Carry, 2022–23
sled, seven dog forms, and
beaded tuppies (dog blankets)
installation: 5 × 25 × 10 ft. floor space
Courtesy of the artist
(See schematic, pp. 80–81)

Geo Neptune

Flower Top with Bird, 2008
black ash, and sweetgrass
approx. 11 × 7 × 11 in.
Courtesy of the artist

CAT. 4.5 (p. 96)

Alewife Barrel, 2013
black ash and sweetgrass
6 ½ × 9 × 9 in.
Courtesy of the artist

CAT. 4.6 (p. 96)

Basket with Cover, 2013
ash splints and sweetgrass with commercial dye
overall: 7 ⅛ × 8 × 2 ¼ in.
National Museum of the American Indian, Smithsonian
Institution, Museum purchase from Molly Neptune Parker,
26/9287

CAT. 4.1 (p. 87)

Feast of the Hummingbirds, 2013
black ash, sweetgrass, and birch
with commercial dye
24 × diam. 10 in.
Courtesy of the artist

CAT. 4.7 (p. 97)

Small Purple Flower Top, 2016
black ash and sweetgrass
with commercial dye
5 × diam. 5 in.
Courtesy of the artist

CAT. 4.8 (p. 97)

Apikcilu Binds the Sun, 2018
ash and sweetgrass with commercial dye,
acrylic ink, and 24-karat gold-plated beads
16 ½ × diam. 9 in.
Bowdoin College Museum of Art, Brunswick, ME, Museum
Purchase, The Philip Conway Beam Endowment Fund

CAT. 4.3 (pp. 90–91)

Piluwapiyit: The Powerful One, 2018
black ash and sweetgrass with commercially
tanned deer skin, brain-tanned deer skin,
cochineal-dyed deer skin, 24-karat gold-
plated beads, freshwater pearls, garnets,
and charlotte-cut glass beads
13 × 8 × 8 in.
Courtesy of the artist

CAT. 4.4 (p. 92)

Heart Medicine (AKA Molly's Berry), 2020
black ash and sweetgrass with commercial dye
6 × diam. 4 ½ in.
Courtesy of the artist

CAT. 4.2 (p. 88)

Strawberry Vine Earrings, 2022
black ash and sweetgrass with commercial dye,
antique French seed beads, antique whiteheart
seed beads, 24-karat gold-plated seed beads,
freshwater pearl, garnet, and wampum beads
approx. 6 × 1 ½ in. each
Courtesy of the artist
CAT. 4.9 (pp. 98–99)

Chief's Moccasins, 2023
silk ribbons, antique and contemporary
seed beads, veau velour heeled boots
by Christian Louboutin
10 × 9 × 7 in.
Courtesy of the artist
CAT. 4.10 (p. 100)

Fabanaki Flint Corn, 2023
black ash and sweetgrass with commercial dye
18 × 36 × 3 in.
Courtesy of the artist
(see p. 84)

*Posonutehketossis
(The Little Basketmaker)*, 2023
black ash and sweetgrass with commercial
dye, hand-dyed and hand-tanned deer skin,
antique micro beads, freshwater pearls,
and semiprecious beads
18 × diam. 10 in.
Private collection
CAT. 4.13 (p. 101)

Redberry Bottoms, 2023
black ash and sweetgrass with commercial
dye, antique and contemporary seed
beads, and leather stiletto heeled shoes
by Christian Louboutin
7 × 9 × 10 in. each
Courtesy of the artist
CAT. 4.12 (p. 101)

Strawberry Lifecycle, 2023
black ash and sweetgrass with commercial dye
10 x 5 x 3 in.
Courtesy of the artist
CAT. 4.11 (p. 100)

Maggie Thompson

The Equivocator, 2021
rope, wire, stockings, thread, and ribbon
42 × 66 × 6 in.
Collection of Hair and Nails
CAT. 5.2 (pp. 108–9)

I Get Mad Because I Love You, 2021–22
glass beads and filament
48 × 72 × 1 in.
Courtesy of the artist
CAT. 5.1 (p. 106)

On Loving, 2022
vinyl, beads, thread, and zippers
four bags: 90 × 42 × 10 in. each
Courtesy of the artist
CAT. 5.3 (p. 113)

Contemporary Native Craft

Bunn-Marcuse, Kathryn B., and Aldona Jonaitis. *Unsettling Native Art Histories on the Northwest Coast*. Seattle: Bill Holm Center for the Study of Northwest Native Art, Burke Museum, in association with University of Washington Press, 2020.

Chambers, Letitia. *Clearly Indigenous: Native Visions Reimagined in Glass*. Santa Fe: Museum of New Mexico Press, 2020.

MacDowell, Marsha L., and C. Kurt Dewhurst. *To Honor and Comfort: Native Quilting Traditions*. Santa Fe: Museum of New Mexico Press in association with Michigan State University Museum, 1997.

Means, Danyelle, and Kat Griefen, et al. *Survivance and Sovereignty on Turtle Island: Engaging with Contemporary Native American Art*. Bayside, NY: Kupferberg Holocaust Center, Queensborough Community College, CUNY, 2020. https://www.qcc.cuny.edu/khc/e-catalogs/Survivance-and-Sovereignty-on-Turtle-Island/index.html.

Mithlo, Nancy Marie, et al. *Manifestations: New Native Art Criticism*. Santa Fe: Institute of American Indian Arts, Museum of Contemporary Native Arts, 2011.

Passalacqua, Veronica, Kate Morris, and James H. Nottage. *Native Art Now!: Developments in Contemporary Native American Art Since 1992*. Indianapolis: Eiteljorg Museum of American Indians and Western Art, 2017.

Yohe, Jill Ahlberg, and Teri Greeves. *Hearts of Our People: Native Women Artists*. Minneapolis: Minneapolis Institute of Art in association with the University of Washington Press, 2019.

Joe Feddersen

ahtone, heather. "Cultural Paradigms of Contemporary Indigenous Art: As Found in the Work of Shan Goshorn, Norman Akers, Marie Watt, and Joe Feddersen." PhD diss., University of Oklahoma, 2018.

———. "Reading Beneath the Surface: Joe Feddersen's Parking Lot." Special issue, *Wicazo Sa Review* 27, no. 1 (2012): 73–84. https://doi.org/10.5749/wicazosareview.27.1.0073.

Dobkins, Rebecca J., and Barbara Earl Thomas. *Joe Feddersen: Vital Signs*. Jacob Lawrence Series on American Artists. Salem, OR: Hallie Ford Museum of Art, Willamette University; Seattle: University of Washington Press, 2008.

Keim, Brandon. *Terrain: Speaking of Home; Artwork by Joe Feddersen*. Washington, DC: Cultural Programs of the National Academy of Sciences, 2022. Exhibition catalogue. http://www.cpnas.org/exhibitions/feddersen_ecat.pdf.

McFadden, David Revere, and Ellen Napiura Taubman. *Changing Hands: Art without Reservation 2; Contemporary Native North American Art from the West, Northwest, and Pacific*. New York: Museum of Arts and Design, 2005.

Sun Valley Center for the Arts. *Crossing Cultures: Ethnicity in Contemporary America*. Sun Valley, ID: Sun Valley Center for the Arts, 2012. Exhibition brochure. https://issuu.com/sunvalleycenterforthearts/docs/crossing_cultures.

Woody, Elizabeth. "Joe Feddersen: Geometric Abstraction—The Language of the Land." In *Continuum 12 Artists*. Washington, DC: National Museum of the American Indian, 2003.

Selected Bibliography

Lily Hope
Ursala Hudson

Belarde-Lewis, Miranda. "Wearing the Wealth of the Land: Chilkat Robes and Their Connection to Place." In *Nature's Nation: American Art and Environment*, edited by Karl Kusserow and Alan C. Braddock, 178–87. Princeton, NJ: Princeton University Art Museum, 2018.

Henrikson, Steve, et al. *The Spirit Wraps around You: Northern Northwest Coast Native Textiles*. Juneau, AK: Friends of the Alaska State Library, Archives and Museum, 2021.

Hope, Lily. "Lily Hope, Featured Artist." By Ana Erickson. *Tidal Echoes* (2021): 64–69.

Hudson, Ursala. "Matriarch Rising [Ensemble]: Inheriting the Angles of an Electrified Heart." *Kadusné*, 2021. http://kadusne.com/works /matriarch-rising-ensemble/.

Fletcher, Amy. "Lily Hope: Tlingit Weaver." *First American Art Magazine*, no. 30 (Spring 2021): 48–53.

Rizal, Clarissa. *Jennie Weaves an Apprentice: A Chilkat Weaver's Handbook*. Juneau, AK: Artstream, 2015.

Samuel, Cheryl. *The Chilkat Dancing Blanket*. Seattle, WA: Pacific Search Press, 1982.

Taylor, Sherry. "Lily Hope: Tlingit Weaver of Chilkat and Ravenstail." *Handwoven*, September/ October 2020. https://handwovenmagazine .com/lily-hope-tlingit-weaver-of-chilkat-and -ravenstail.

Erica Lord

Askren, Mique'l Icesis. "Erica Lord." In *Manifestations: New Native Art Criticism*, edited by Nancy Marie Mithlo et al., 132–33. Santa Fe: Institute of American Indian Arts, Museum of Contemporary Native Arts, 2011.

Carnahan, Alanna. "From Native Modernism to Native Feminism: Understanding Contemporary Art." Master's thesis, California State University, Long Beach, 2019.

Daniher, Colleen Kim. "The Pose as Interventionist Gesture: Erica Lord and Decolonizing the Proper Subject of Memory." *E-misférica: Decolonial Gesture* 11, no. 1 (2014), https://hemisphericinstitute .org/en/emisferica-11-1-decolonial-gesture /11-1-essays/the-pose-as-interventionist-gesture -erica-lord-and-decolonizing-the-proper-subject -of-memory.html.

Eldred, Michole. "Tapis: Blankets in Celebration of the Sled Dog." *First American Art Magazine*, no. 24 (Fall 2019): 20–25.

"Erica Lord." In *Survivance and Sovereignty on Turtle Island: Engaging with Contemporary Art*, edited by Danyelle Means and Kat Griefen, 32–33. Bayside, NY: Kupferberg Holocaust Center; Queensborough Community College, CUNY, 2020. https://www.qcc.cuny.edu /khc/e-catalogs/Survivance-and-Sovereignty -on-Turtle-Island/index.html.

Evans, Lara M. "Setting the Photographs Aside: Native North American Photography since 1990." In *Native Art Now!: Developments in Contemporary Native American Art since 1992*, edited by Veronica Passalacqua, Kate Morris, and James H. Nottage, 248–49. Indianapolis: Eiteljorg Museum of American Indians and Western Art, 2017.

Evans, Lara M. "The Artifact Piece and Artifact Piece, Revisited." In *Action and Agency: Advancing the Dialogue on Native Performance Art*, edited by Nancy J. Blomberg, 63–88. Denver: Denver Art Museum, 2010.

Evans, Lara M., and Mique'l Dangeli. "Indigeneity and the Posthumous Condition." In *Posthumous Art, Law, and the Art Market: The Afterlife of Art*, edited by Sharon Hecker and Peter J. Karol, 200–213. New York: Routledge, 2022.

Neptune, Geo. "Wabanaki Basketmaking Traditions under Threat? Art, Culture, and the Future of Maine Indian Basketmaking." UNE Maine Women Writers Collection, October 2, 2018. Video, 1:29:51. https://youtu.be/2_Vg2aZhB_0.

Reynolds, Daniel. "Geo Soctomah Neptune, Out100 2021: 18 LGBTQ+ Policy Makers and Advocates Changing the World." *Out Magazine*, November 3, 2021. https://www.out.com/print/2021/11/03/out100-2021-18-lgbtq-policy-makers-and-advocates-changing-world#media-gallery-media-8.

Vanderhoop, Carrie Anne. "Geo Soctomah Neptune: Reclaiming Tradition." *nbo: National Basketry Organization* 70 (Spring 2018): 22–26. http://nationalbasketry.org/wp-content/uploads/2021/02/Geo-Neptune.pdf.

Geo Neptune

Mertz-Edwards, Jean. "George Neptune." *First American Art Magazine*, no. 9 (Winter 2015/16): 56–61.

Montiel, Anya. "LGBTQIA+ Pride and Two-Spirit People: We Are Not Separate from Our Communities: LGBTQIA+ Pride and Two-Spirit People." *Smithsonian Voices*, June 23, 2021. https://www.smithsonianmag.com/blogs/national-museum-american-indian/2021/06/23/lgbtqia-pride-and-two-spirit-people.

Mundell, Kathleen. *North by Northeast: Wabanaki, Akwesasne Mohawk, and Tuscarora Traditional Arts*. Gardiner, ME: Tilbury House, 2008.

Maggie Thompson

Combs, Marianne. "Maggie Thompson Weaves Together Her Indian Identity in 'Where I Fit'." *State of the Arts Blog*, March 14, 2014. https://www.mprnews.org/story/2014/03/14/maggie-thompson-weaves-together-her-indian-identity-in-where-i-fit.

Felder, Rachel. "Pantyhose That Make You Think." *New York Times*, September 27, 2019. https://www.nytimes.com/2019/09/27/arts/design/pantyhose-gossamer-margate.html.

Grey Eagle, Jaida. "How Makwa Studio Knits Together Art, Activism, and Business." *Minnesota Monthly*, March 8, 2021. https://www.minnesotamonthly.com/lifestyle/style-shopping/how-maggie-thompson-at-makwa-studio-knits-together-art-activism-and-business.

Guerber, Megan. "Maggie Thompson's Quilt Collaboration." *American Craft Council*, December 8, 2017. https://www.craftcouncil .org/post/maggie-thompsons-quilt-collaboration.

Kourlas, Gia. "Under the Stars and Quilts, with Randalls Island as Her Stage." *New York Times*, August 11, 2017. https://www.nytimes.com /2017/08/11/arts/dance/under-the-stars -and-quilts-with-randalls-island-as-her-stage .html?smid=url-share.

"Makwa Studio." *American Craft Magazine*, December/January 2017. https://www .craftcouncil.org/magazine/article/makwa -studio.

Sauer, Lauren. "Bridging the Gap: Maggie Thompson Uses Art to Navigate a Contemporary Native American Identity." *Growler*, March 26, 2019. https://growlermag.com/bridging-the-gap -maggie-thompson-uses-art-to-navigate-a -contemporary-native-american-identity.

Image Credits

SHARING HONORS

Renwick Invitational 2023

Lara M. Evans, Miranda Belarde-Lewis, and Anya Montiel,

foreword by Stephanie Stebich

AND BURDENS

Published in conjunction with the exhibition of the same name, on view at the Renwick Gallery of the Smithsonian American Art Museum, Washington, DC, from May 26, 2023, to March 31, 2024.

Produced by the Publications Office, Smithsonian American Art Museum, Washington, DC, americanart.si.edu

Tiffany D. Farrell | *Head of Publications*
Julianna C. White | *Managing Editor*
Rosemary Hammack | *Editor*
Denise Arnot | *Designer*
Aubrey Vinson | *Permissions Coordinator*

Published by the Smithsonian American Art Museum in association with University of Washington Press, Seattle (uwapress.uw.edu).

The Smithsonian American Art Museum is home to one of the largest collections of American art in the world. Its holdings—more than 43,000 works—tell the story of America through the visual arts and represent the most inclusive collection of American art in any museum today.

It is the nation's first federal art collection, predating the 1846 founding of the Smithsonian Institution. The museum celebrates the exceptional creativity of the nation's artists whose insights into history, society, and the individual reveal the essence of the American experience.

The Renwick Gallery became the home of the museum's American craft and decorative arts program in 1972. The gallery is located in a historic architectural landmark on Pennsylvania Avenue at 17th Street, NW, in Washington, DC.

For more information, write to:

Office of Publications
Smithsonian American Art Museum
MRC 970, PO Box 37012
Washington, DC 20013–7012

Typeset in Gibson, Henderson Sans, and Conduit. Printed and bound in Italy, by Conti Tipocolor, on 150 gsm Condat matt Périgord paper.

Library of Congress Cataloging-in-Publication Data

Names Renwick Invitational (Exhibition) (10th : 2023 : Washington, D.C.), author. | Evans, Lara, curator. | Belarde Lewis, Miranda. | Montiel, Anya. | Stebich, Stephanie A., writer of foreword. | Renwick Gallery, host institution.

Title Sharing honors and burdens : Renwick Invitational 2023 | Lara M. Evans, Miranda Belarde-Lewis, Anya Montiel ; foreword by Stephanie Stebich

Description Washington, DC : Renwick Gallery of the Smithsonian American Art Museum ; Seattle : in association with University of Washington Press, [2023] | "Published in conjunction with the exhibition of the same name, on view at the Renwick Gallery of the Smithsonian American Art Museum, Washington, DC, from May 26, 2023 to March 31, 2024." | Includes bibliographical references.

Identifiers LCCN 2022049886 | ISBN 9780937311882 (paperback)

Subjects LCSH: Indian art—United States—21st century—Exhibitions.

Classification LCC N6538.A4 R46 2023 | DDC 704.03/97—dc23/eng /20221115 LC record available at https://lccn.loc.gov/2022049886

10 9 8 7 6 5 4 3 2 1

PRINTED IN ITALY

Smithsonian American Art Museum

UNIVERSITY OF WASHINGTON PRESS